Dartmoor 2001

A Dartmoor Diary of Yesteryear

GW00480801

By MIKE BR

A Subscriber Edition
limited to 750 copies

Signed: *Mike Brown*

Number: 384

FOREST PUBLISHING

First published in 2001 by FOREST PUBLISHING, Woodstock, Liverton, Newton Abbot, Devon TQ12 6JJ

British Library Cataloguing in Publication Data

A catalogue record for this book is available from the British Library.

ISBN 0–9536852–2–5

Forest Publishing

Editorial, design and layout by:
Mike Lang

Typeset by:
Carnaby Typesetting, Torquay, Devon TQ1 1EG

Printed and bound in Great Britain by:
The Latimer Trend Group, Plymouth, Devon PL6 7PL

Cover photographs:

Front – The Face of Dartmoor's Past – the Dartmoor landscape at the dawn of the Third Millennium BC – Hut Circle at Grimspound (q.v. March 31st).

Back – The Face of Dartmoor's Future – young Dartmoor villager at the dawn of the Third Millennium AD – Emma Wills, Lustleigh May Queen 2000 (q.v. May 6th).

Contents

Introductory Notes & Acknowledgements

To celebrate the *real* new millennium, and following on from the success of *Dartmoor 2000: A Chronological Review of the Past Millennium*, I decided to complete another project which had been ongoing for some time – a compilation recording selected episodes from Dartmoor's history in a 'Dartmoor Diary of Yesteryear'. This book, in which the entries are presented in similar format to the previous title, represents the results of my researches, and I hope that it will form a useful addition to the bookshelves of everyone with an interest in Dartmoor.

The present title principally covers the post-medieval period, the vast majority of the historical entries having been selected from original archive materials which I, myself, have studied: these include not only documents, ledgers and old newspapers, but also memorials, which most people would not consider as 'archives' even though, of course, a number of epitaphs contain historical data which is not available in any other 'written' form. I hope, therefore, that by having used this method for the compilation that most of the information provided, and the events, incidents and other occurrences to which reference is made, will be new to most readers.

To enable me to complete the compilation, as well as to broaden the period covered, I also consulted a number of previously published transcripts and have included notice of some events from more remote periods of history. In addition, I made recourse to a small selection of more recent publications in order to enable me to cover some events which have taken place within living memory. Mention of the latter will, hopefully, bring back personal recollections for those who were involved in them, or who lived in the places concerned, and might jog the memories of others who will recall reading about them when they occurred.

To this end I have also included mention of events which took place on Dartmoor during the millennium year itself – that which was officially designated the 'millennium year', to which declaration we all had to conform whether we liked it or not! Many events and celebrations took place on Dartmoor during the year 2000 – or Y2K as it also became known! – and the most notable of them are recorded herein.

As already stated, the bulk of the information provided in the 'Diary' has been gleaned from archive materials. By far the majority of these entries are from documents and ledgers which are held in various parish and manorial collections in the City of Plymouth & West Devon Record Office, and my thanks are due to the archivists and other staff there for their past assistance with my various research projects.

In the absence of a list of references – a list which would take up far too much space – due acknowledgement is hereby also given to the authors of all previously published articles and papers which have been consulted for the compilation of this book, as well as to the editors and societies in whose magazines or journals these articles and papers appeared. Without the work of these writers, amateur enthusiasts and qualified historians alike, I would not have been able to provide a complete 'Dartmoor Diary of Yesteryear', let alone have filled it with such a varied amount of information from all periods of history.

This, indeed, was one of my main aims, and I hope that the range of topics covered by the extracts selected for inclusion is broad enough to satisfy readers with a wide variety of different interests. And, if some of these entries fire their imaginations, prompting them to seek out further information on some of the events or incidents featured – or, in the case of more recent events, bring back personal memories or recollections – then the book will have successfully accomplished part of what it set out to achieve.

Mike Brown,

Lady Day 2001

❋❋❋❋❋

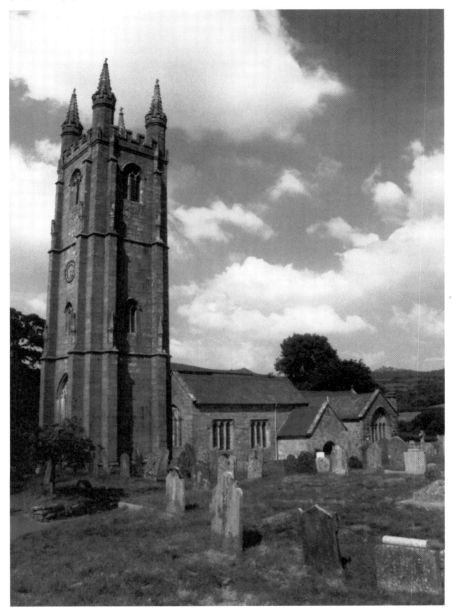

St Pancras, Widecombe, one of the Dartmoor churches whose bells rang out at midday on January 1st 2000 to usher in the new millennium (q.v. January 1st).

January

1st **2000.** To usher in the new millennium, churches across the nation ring their bells at midday. Among Dartmoor churches to take part in these celebrations are Ashburton, Brentor (Christchurch), Brentor (St Michael's), Chagford, Gidleigh, Holne, Huccaby, Ilsington, Leusdon, Lydford, Mary Tavy, Meavy, Moreton-hampstead, Peter Tavy, South Tawton, Tavistock and Widecombe.

2nd **1773.** Tamar Bertch alias Thomasine Burch is arrested as a "rogue and vagabond" in Wellington, Somerset, and ordered to be removed back to Ugborough. An inmate of the Ugborough workhouse (when she was there!), Tamar evidently determined to see something of the world before she was given her pauper's funeral, and further travels in the early 1770s took her to places as far afield as London, Hungerford (Berkshire) and Truro.

3rd **1926.** A new stained-glass window in Dean Prior Church, to the memory of the poet Robert Herrick, former vicar of Dean, is dedicated by the Reverend J. Perry-Keene, the present incumbent.

2000. The Dartmoor 2000 Project is first with the millennium news! Reports of Dartmoor area millennium beacon-lightings and bell-ringing, plus other local news, are flashed around the world at the start of the ambitious internet-based project to create a permanent record of 'Life on Dartmoor in the Millennium Year'.

4th **1728.** William Carew leases Winscombe in Drewsteignton to William Ponsford. The heriot clause in the lease reads as follows: "And also Yielding & Paying at & upon the decease of every of them the said William Ponsford junr Joan Cann & John Ponsford they dying successively & in order as they are herein named the Best beast of the Lessee Assignee or Occupant of the said Premises...for & in the name of a Heriot or Farlief". Excluded from the tenant's rights are "all Quarries of blue Slate or hilling stones & lime stone And also all Tinn Toll-tinn Copper & all other Metals whatsoever".

1926. The new school opens at Meavy. On the menu for the guests is a choice of roast beef, chicken and ham, or leg of mutton, followed by plum pudding, mince pies, trifle, and cheese and celery. School meals at Meavy have probably never been quite the same since!

5th **1770.** The vast roof span of the huge church at Ugborough needed enormous quantities of helling stones (slates) on a regular basis. On this day another two thousand are delivered, from the quarry owned by Elizabeth Hodge, at a cost of just 10s (50p). During a period before the term 'inflation' had been invented, they were still being supplied at the same price – equivalent to 25p per 1,000 – 30 years later, by which time her grandson, Henry Damerell Hodge, had become the quarry owner.

6th **1838.** From the *Plymouth Devonport & Stonehouse Herald*: "Galley alias Turpin, the accomplice of Buckingham Joe...has since been liberated". He had been falsely implicated, and sentenced, for the 1835 murder of Jonathan May, near Moretonhampstead. The newspaper report was, in fact, somewhat premature, for Galley was "liberated" from a prison hulk on the Thames at Woolwich and transported to Australia, and it was not until 1879 that he was finally pardoned, and returned to this country.

1858. Mary Trant, housemaid at Buckland Court, is discharged for "general misconduct and familiarity with the butler".

7th **1667.** Sir William Strode of Newingham issues a reversionary lease on Loviton in Mevy to Alexander Elford of Mevy, with a directive that the latter shall perform "suite to all the Courts of the

This is all that remains of the most modern house at Deancombe (q.v. January 8th).

said Sir William Strode...to bee holden within his mannor of Calisham...as other Tenants there doe or ought to doe".

8th **1847.** Richard and Margaret Andrews relinquish their interest in East Deancombe, Walkhampton, in return for an annuity of £20.

1905. Philip Blight is buried in South Brent Church. He had been appointed first postman in the town in 1868, and served in that capacity for 33 years.

9th **1836.** James Shortridge, millwright of Horrabridge, is requested to provide an estimate for "making & fixing and setting to work a new and good Smut Machine, and setting to rights any other part of the Machinery that may be found out of order", including the installation of a new French millstone. His estimate was accepted, and the work was carried out later in the year, for which his charge was £33 10s (£33.50p).

1851. At a vestry, the parishioners of Whitchurch agree to build new stables for the parish. The resulting building still stands opposite the churchyard, and the date-stone, which John Toop provided for it, is still in situ.

10th **1646.** General Fairfax lodges overnight at the Mermaid Inn, North Street, Ashburton.

The entrance to Ashburton's old Mermaid Inn, now an ironmonger's (q.v. January 10th).

1829. James Elliott is paid £8 6s 8d (approx £8.33p) for "Surveying the Parish of Ugborough for a new poor Rate".

11th **1348.** Having been instituted as vicar of Ashburton only ten days earlier, Sir Richard Yurl dies of the Black Death.

1752. Stephen Nosworthy pays a mortuary fee of ten shillings (50p) to the rector of Manaton following the death of his father.

12th **1883.** The *Tavistock Gazette* carries an interesting report on a letter received from "a well known townsman" (unfortunately not named) who had emigrated to Australia two years earlier. The unknown correspondent reports that he and his son, living in Sydney, are paid 10s to 13s (50p to 65p) per 8-hour working day, and that they have "plenty to eat and drink, and plenty of money to buy with". However, "sometimes it is rather too hot to be comfortable, and the mosquitoes are rather troublesome in summer". He bought two plots of land after landing, at 18s (90p) a square foot, and soon afterwards another plot at 10s (50p) a square foot. On the latter he intends to build two cottages to let at 8s (40p) a week each. He also says that "we are apt sometimes to forget where we are", for most of the people living in the houses nearby are from Horrabridge, Princetown, Launceston, Torquay and Plymouth!

13th **1679.** James Bremblecombe alias Clark of Drewsteignton marries Joane Pounsford of Drewston. As with all but one instance of the hundred or so surname aliases which have been noted from various Devon parishes during many years of research, the origins of this one, which is perpetuated through (at least) three consecutive generations of the Bremblecombe family, is a complete mystery.

14th **1884.** A letter from Whitehall is received by the churchwardens of Buckland Monachorum telling them that, for health reasons, "Burials [must] be discontinued forthwith and entirely in the parish church of Buckland Monachorum...and also in the churchyard".

15th **1875.** Wide-screen cinema comes to Tavistock! Yes, really! The *Tavistock Gazette* advertises a forthcoming lecture in the town hall, by the Reverend L. H. Byrnes, on the ascent of Mont Blanc. The lecture will be illustrated with "magnificent dissolving views... brilliantly illuminated by the oxy-hydrogen lime-light with musical accompaniments". A short report in the following week's edition of the newspaper proclaims that "a more agreeable and instructive entertainment has never [before] visited Tavistock".

Quite how the curiously-named apparatus worked is not explained but, according to the report, each of the forty or so "dissolving views" shown (in sequence) spanned an entire wall of the lecture-room, a width of nearly 20 feet!

16th **1721.** The deed of sale of South Godsworthy, Peter Tavy, from Andrew Whiddon of Moretonhampstead to John Skinner of Peter Tavy, refers to part of the property as "All That Toft or old Decayed Messuage or Dwellinghouse Situate and being in South Godsworthy...And one Close or Parcell of Land and Pasture Called the Chillepark And one Meadow Called the Shutta-meadow".

17th **1768.** Thomas Vivian, vicar of Cornwood, issues a notice forbidding the occupiers of Ford, Hele, Rook, Cross, and other places, "from diverting the Vicarage pot-water without leave".

18th **1940.** The *Falkland Islands News Weekly* carries a report on the burial at Port Stanley of two crew members of *HMS Exeter*, who had died of wounds sustained during the Battle of the River Plate (the ceremony itself had taken place a month earlier). A number of men from Dartmoor parishes also served on *HMS Exeter*, a Devonport-based cruiser.

19th **1721.** A suit is later brought by Martin Ryders Esq alleging that, on this day in 1721, John Moses "...with force of arms...the Plaintiff's Close called Wigford Down als Wigborough Down...did break and ten Loads of Turf...in the said Close to the value of £10 did cut take and carry away and Ten Loads of the Soyle...and ten Loads of Stones...".

20th **1653.** In answer to a suit brought by Richard Cabell against William Ellacot, miller at the Kilbury Mills, Buckfastleigh, two other defendants state that "Kilbury Mills are very auntient mills...and in goodenesse...farre exceed and surpasse the...Towne Mills", and further claim that the miller at Cabell's Towne Mills takes too much in toll, and does not perform the grinding correctly, whereas the work done by Ellacot "be very beneficiall...to these defendants and others".

1853. Benjamin Stapleton, found guilty of poaching in Buckland Monachorum, choses imprisonment as an alternative to paying a fine and costs amounting to 19 shillings (95p).

1927. The Meavy Village Drama Society performs *My Man John* at the Plympton Guildhall.

21st **1647.** Thomas Harragrove issues a lease to William Walter of "All that Tenement in Lydford called or known by the name of

The unfinished cross near the summit of Rippon Tor (q.v. January 21st).

Woteknill lying betweene the Landes of Thomas Woode E
River of Leed...the Way leading to the Prince his Milles...anu υιc
Landes of the heirs of John Moore Esq deceased and William Code
Esq...".

1871. John Luscombe of Rook, aged 71, is the first to be buried in
the new extension of the graveyard at Cornwood.

1885. William Crossing visits Rippon Tor for the purpose of
seeking out and examining the cross on its summit.

22nd **1612.** John Ball, Henry Paddon, William Furse and John Hall are
fined a shilling (5p) each by the Ashburton overseers for
"absentyne themselves from the Church on the Sabbath daye all
the tyme of divine service".

1910. Richard A. Toop, butcher of Horrabridge, receives a
payment of 12s (60p) from the trustees of the Cawte Lands Charity
in Sheepstor, for having supplied "Xmas Meat for Brown,
Glanville & Parker".

23rd **1759.** Aside from leaving his property, Hooks, to his wife, Sarah,
the principal bequest in the will of Robert Elliott of Ashburton,
carpenter, is £15 to his son, Charles, for the latter to teach his other
son, Robert, in carpentry.

24th **1654.** The body of John Browne, buried on January 20th 1654 in the
graveyard at Ashburton is "taken up again on the 24th then
buried in the High way near Gooseapoole".

25th **1759.** Forty young ash trees are planted at South Tawton "in the
middle Hedge of the Glebe and the lower Hedge parting the
Centery Ground".

1990. Hurricane-force winds lash the entire southern half of the
country, laying waste huge swathes of plantations and
woodlands. Around 10% of the trees on Dartmoor are brought
down.

26th **1717.** Richard Raddon is appointed sexton of Ilsington.

1837. The obituary report on 90-year old Margaret Rowe, widow
of James Rowe of Gidleigh, states that she left 9 children, 59
grandchildren and 65 great-grandchildren to mourn her death.

27th **1942.** The Dartmoor artist F. J. Widgery dies.

28th **1761.** Stephen Townsend of Widecombe is declared to "not be
entitled to any Reward from ye Parish for killing of Foxes" (under
the Act for the Destruction of Vermin) until he has brought in
enough to cover a £5 fine imposed on some local farmers for
killing a hare, a fine imposed upon them because Townsend had
informed on them. The going rate for killing a fox in most of the

The aftermath of the storms of 1990 – fallen trees beside the East Dart at Bellever (q.v. January 25th).

Dartmoor parishes at the time was around 6s 8d (approx 33p), which meant that Townsend would have had to bring in fifteen of them to compensate for what the churchwardens describe as "his vexatious proceedings".

29th **1921.** *The Illustrated Western Weekly News* reports that the bells of Buckfast Abbey had been rung for the first time during the previous weekend. A photograph of the west elevation of the abbey is also published, showing the building, still far from completion, cloaked in scaffolding. The same issue, by the way, also carries advance news of what turned out to be the non-event of the century: a report on a partial eclipse also makes reference to the total eclipse due to take place on June 29th 1927, which would be visible from Yorkshire, and then observes that "after that there will not be another until 1999, which will, however, be visible from Cornwall".

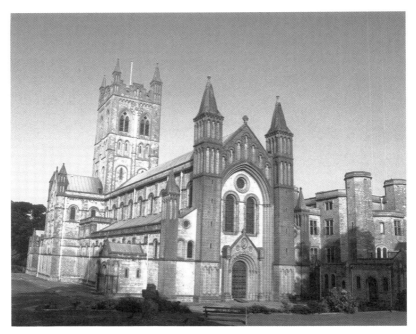

Buckfast Abbey, the bells of which first rang in 1921 (q.v. January 29th).

30th **1720.** In his will Matthew Atwell, rector of Moretonhampstead, leaves "All that my Messuage & Tenement called Will Town and

All my Lands within the parish of Walkhampton...and All that my said Messuage and Tenement called Lower Ditsham" to his son, Joseph.

31st **1857.** Whitchurch parishioners decide to take the Tamar Granite Company to court over the "injury done to Whitchurch Down by the passage of the Granite Waggons across the turf" and also for "encroachments made on the same".

✳✳✳✳✳

February

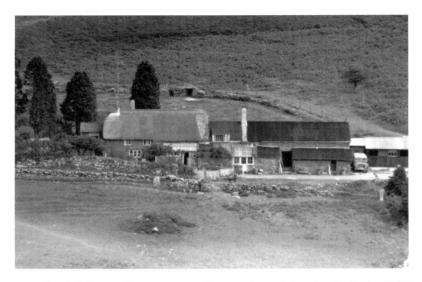

Headland Warren Farm, scene of a tragic and lonely death in 1778 (q.v. February 1st).

1st **1778.** Ann Waters dies at Headland Warren. The entry in the register of North Bovey, where she is buried two days later, records that she was "supposed to be an Apprentice in the parish of Dawlish & removed from thence to Moreton-Hampstead & from thence to Headland in this parish the better to secure privacy of her Delivery of a child".

2nd **1711.** Walter Northmore surrenders his old lease on part of Torr in Sheepstor and pays a fine of two guineas for a new lease on the lives of George Northmore, Richard Northmore and Robert Tripe. The rent for the little tenement is just 5s 2d (just over 25p) per annum. The farliue payable upon the deaths of each of the lives – rather a contradiction in terms! – is set at 11s (55p).

3rd **1891.** The Board of Charity Commissioners issues a new scheme for regulating the Manaton Church House Charity.

4th **1881.** The sum of £1 10s 6d (£1.52$\frac{1}{2}$p), collected from the officers of Dartmoor Prison, is handed over to the treasurer of the fund for

the families of the victims of the East Wheal Crebor Mine disaster. A headstone to three of the victims, who were drowned on the fateful day in the previous July, William J. Cloak, Thomas Allen and Henry Hill, stands in the Dolvin Road Cemetery, Tavistock.

5th **1656.** John Palmer of Tavistock marries Florence Warren. The marriage is recorded in the Tavistock register but, as with many Tavistock marriages which took place during the interregnum, they are said in the register entry to have been "married at Shittester [Sheepstor]". John Elford is one of the local justices responsible for conducting civil marriage ceremonies during this period, and it is likely that the couple were married in the chapel at Longstone. (Other places were also used for the ceremonies, eg. Killworthy, where couples were married by Justice John Glanville.)

This granite lectern, rescued from the old chapel at Longstone Manor, now stands on private ground near Burrator Lodge (q.v. February 5th).

6th **1634.** In his will Christopher Hamlinge the elder of Widecombe, yeoman, leaves to his son, James, "all my part in a tin work called Bracktor in Maniton", and to his son, Thomas, "all my part being one dole and quarter of a dole in a tin work called Knacke within the Stanery of Ashburton".

1675. From the Drewsteignton registers: "John Laskey of Uppadon was denounced Excommunicate in the parish church of

Drewsteignton on Sunday ffebruary the 6th AD 1675 by the order of the Lord my Bp. of Exon. (holding the Arch-Deaconry of Exon. in Comenda)..."

1792. William Jenkins of Plymouth signs a bond in the sum of £10 as surety that his friend, Nathaniel Trist, "shall Appear Before John Bulteel Esq to answer the Complaint of the Churchwardens & Overseers of the Poor of the Parish of Ugborough". Trist was accused of being the father of Mary Tippet's illegitimate child. He duly appeared and, very unusually in such cases, was found not guilty.

7th **1900.** A Mr Ryce gives a lecture on artificial manures at South Brent and, according to a report in the *South Brent Times* three days later, "with the aid of the optical lantern demonstrated the value of certain organisms found in the soil".

8th **1643.** Royalist dragoons, under the command of Berkeley and Ashburnam, attack Northcote's Parliamentarians quartered at Chagford. During the skirmish Sidney Godolphin is shot and bleeds to death in the porch of the Three Crowns Inn. He is later buried at Okehampton.

1838. At the Lopes Arms Inn, at Jump (Roborough), 1,050 oak, 113 ash, 20 elm and various other timber trees and bark etc, in woodlands at Bickleigh and Shaugh Prior belonging to the Maristow Estate, are sold by auction.

9th **1801.** A summons is issued against the overseer of Ugborough, calling him to appear before the justices "shew cause if he can why the act for the better relief of the poor has not been carried into effect in the said parish and to answer the Complaint of William Harris and other poor men of the said parish".

1934. The Duchy of Cornwall conveys to the Ecclesiastical Commissioners "all that piece of land...situate at Postbridge ...within the Manor of Lydford and Forest of Dartmoor together with the Building intended for use as a church standing thereon for an intended new church to be called the Church of St Gabriel Postbridge".

10th **1590.** John Wolcombe alias Bawden lets his tenement called Trailesworthie in Shaugh Prior "with comon of pasture turbery ffurze and heath in Leigh more...and comon of eastovers howesboote and foldboote in Bicklighe Woode" to William Strode of Newinham for an annual rent of 57s 4d (approx £2.87^1/2p).

1894. Henry Sage of Meavy commits suicide by cutting his throat with a knife.

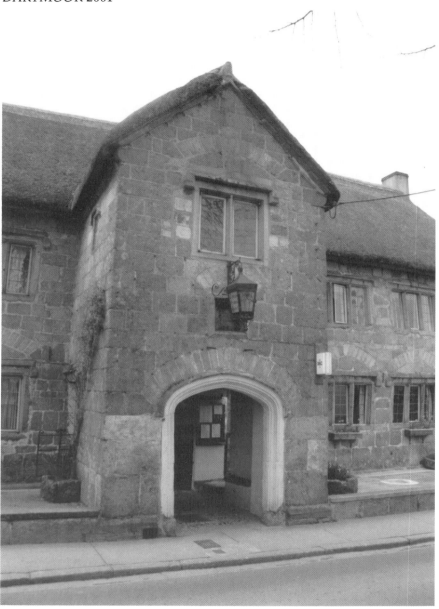

The entrance to the Three Crowns Inn, where Sidney Godolphin was shot in 1643 (q.v. February 8th).

The old kennel court, or dog pit, at Trowlesworthy Warren House (q.v. February 10th).

1900. According to a press report, an unnamed client of Mr A. Bromley Sanders of Exeter buys the Valiant Soldier Inn at Buckfastleigh for £1,700. The secret identity of the mystery buyer is out! It was the Exeter brewery of Norman & Pring. The vendor was Joseph Hoar, who had bought the inn in 1885 for £575.

11th **1811.** An advert for letting Peekhill Farm in Walkhampton, placed in the *Sherborne Mercury*, describes the property as comprising "a good farm-house, barn, stable, shippens, and other convenient outbuildings, and about 70 acres of very good arable, meadow, and pasture land, with right of common on the extensive wastes belonging to the Manor of Walkhampton, next adjoining the Forest of Dartmoor".

12th **1678.** In the second of a pair of deeds reciting a rather complex property transaction, Richord Mann conveys part of a property at Paidge's Well, Sampford Spiney, back to John Wedlake for him to build a new house next to an existing one, built by Wedlake a few years earlier. On the previous day Wedlake had conveyed the entire property to Mann, who then became the tenant of the house which had already been built. Why the exchange had to be undertaken in this roundabout way is not perfectly clear.

1820. An account entry of this date hints at the rather extreme measures previously adopted in order to secure the eviction of the

Bowden family from a dwelling at Brisworthy: "Paid William Ellis the Masons Bill for Repairing a Wall & Slating of Mr Peck's House at Brisworthy, which was damaged by pulling down the House the Bowden's took possession of". The total demolition of the house in which they had taken up residence doubtless had the desired effect, and prompted the Bowden family to seek alternative accommodation!

13th **1656.** John Foxford is sworn in as register of Manaton. (Note the spelling – the officials who, during the Commonwealth, took charge of recording baptisms, marriages and burials were not called registrars!)

1787. Joseph Spurr is granted a lease of Clasiwell, Walkhampton, with "liberty to inclose about Eight Acres of the Commons next adjoining the said Premises". It is likely that Spurr also erected the nearby building now known as 'Colliers' in order to provide winter accommodation for the additional livestock which this extension of the Clasiwell smallholding would have enabled him to keep.

The ruins of the dwelling house at the little tenement of Clasiwell, where Joseph Spurr and his family lived in the late 18th century (q.v. February 13th).

1951. Electric street lights are switched on in Cornwood village for the first time.

14th **1949.** An advert in the *Western Morning News* advertises half-day

rail trips from Plymouth to Yelverton or Horrabridge for 1s 6d (7^1/$_2$p) and to Tavistock or Whitchurch Down for 2s (10p). Quite how the train was to get onto Whitchurch Down is not explained!

15th **(Yearly).** The sundial on the south porch of Ugborough Church is correct on this day, and this day only – yes, seriously! According to an early 20th century report (unfortunately undated) by a Plymouth clockmaker, because Ugborough is "...situated 3^1/$_2$ degrees of longitude west of Greenwich the sun reaches the meridian 15 minutes later, this only permits agreement with the clock once a year 15th February". In October the sundial at Ugborough is as much as 32 minutes out.

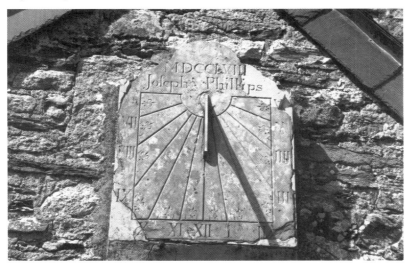

The sundial on Ugborough Church – probably denoting the incorrect time! (q.v. February 15th).

16th **1793.** Bill posters are placed in prominent locations in Ashburton offering two guineas (£2.10p) bounty money to every able-bodied man who is willing to join Captain Hill and enrol in the Navy.
1830. John and Thomas Foot are paid £325 for "Building 5 new Cottages on the scite of the old White Hart Inn at Horrabridge".
1890. "All the rustic population of Postbridge, and all the Dartmoor tin miners from the East and West Vitifer, Birch Tor and Golden Dagger Mines, also from the Great Hensroost Mine... assembled at Ringhill". So reads the opening clauses of an account of the funeral cortege of Jonas Coaker, the self-styled 'Dartmoor Poet'.

17th **1853.** A report on the deaths of Corporal John Panton, and Privates George Driver and John Carlin, of the 7th Regiment Royal Fusiliers, appears in the *Plymouth & Devonport Weekly*. The soldiers are commemorated by a plaque in Princetown churchyard.

18th **1870.** George Jackman is fined 10s (50p) at the Tavistock magistrates court for an offence against the Contagious Diseases (Animals) Act. During the previous month he had gathered his flock from Whitsun in Beer Ferris, a farm known to be infected with sheep scab, and driven it back to his farm at Sheepstor.

19th **1281.** Henry and Joan Tregoz grant the manor of Ferthedele (Fardle) to William and Alice Newenton, in exchange for the manor of Dunsydiock (Dunchideock). This was just one of many hundreds of such exchanges conducted by various parties during this and the following century, as gentry families sought to consolidate, and concentrate, their scattered holdings to form coherent estates.

20th **1583.** From the Dean Prior registers: "John Bradford being excommunicated was buried without service in a corner of the churchyard by the suite of his fryndes xx Feb 1583".

1772. The parish registers of Belstone are burnt in an accident. The rector attempts to retrieve what he can from the charred pages, and on a page of a newly-purchased register records some previous entries, "the whole number recovered from the burnt scraps of the old register".

21st **1797.** Sarah Richards is buried at Tavistock. Her burial entry in the register describes her father, Robert, as a "card maker". These were wooden wool cards, or combs, used for combing out and separating the fibres on woollen looms. During this period they were sold at about 1s (5p) per pair.

1914. The body of William Donaghy of Liverpool is discovered near Hartland Tor. How he came to be there, and his exact movements since leaving his native Liverpool three months previously, remain unsolved mysteries to this day.

22nd **1704.** The will of William Meade of North Bovey, "warreyner", leaves "All the right Title Claims Term & Interest wch I have or ought to have in a certain Tenemt called Detsworthy Situate lying & being within the pish of Shutstow [Ditsworthy in Sheepstor] unto my Kinsman Edward Meade and to his three Sisters the rents & profitts of the Same to be Equally Divided between them...".

1837. Thirty-one-year old William Tasker is killed in a "moveable vehicle near the Lower Lodge, Spitchwick".

23rd **1797.** A removal order is issued against Robert Woodley of Moretonhampstead ordering him, and his family, to be sent to Ugborough under the settlement laws. However, the eviction of his wife, Martha, is suspended pending the birth of her child. The child was born on 5th March, and ten days later the doctor declared that the pair were fit to be removed to Ugborough, where the family was shortly afterwards reunited.

24th **1566.** A document bearing this date has been described in various original and published sources as bequeathing Ruddycleave Farm to the church of Buckland-in-the-Moor. Not only does the document clearly not make such a bequest, but it is thought to be a forgery, as indicated by the conclusions of a late-18th century Charity Commissioners' report: "...upon careful examination of the document...our decided opinion...[is]...that the whole is a fabrication...".

1787. A bill for board and lodgings at an inn run by Thomas Bower of Ugborough reveals that his charge for a bed for the night is just 2d (less than 1p), and all meals (breakfast, dinner and supper) are 3d each (approx $1^1/_2$p).

1790. John Marshall gives six cottages to a group of Whitchurch trustees, to house single men or women who by age, accident, infirmity or ill health are "unable to maintain themselves by their own exertions". Amongst the terms and conditions, including giving each occupant 5s (25p) weekly, the occupants are also to be given £1 extra every 24th February, the birthday of the benefactor's late wife, in whose memory the cottages are given. The dwellings were later to become known as 'Mrs Marshall's Memorial Cottages'.

25th **1696.** John Hole of Moretonhampstead sells a moiety (half) of Pudsham Wood in Buckland-in-the-Moor to Edward Hall and John Dingle for £40.

26th **1862.** The surveyors of the Plymouth & Tavistock Turnpike bring a case against Samuel Witheridge for not cleaning the drains beside the turnpike road adjoining his property in Whitchurch. There apparently being some debate as to the true meaning of the clause of the Act under which the action had been brought, the defendant is fined just 6d ($2^1/_2$p) for failing to perform what had, in fact, been a statutory requirement of landowners since the 1555 Highways Act.

27th **1656.** Sir Nicholas Slanning pays Christ's College, Cambridge, £94 15s arrears owed to them on an annual rent charge due from

Walkhampton Manor.

28th **1868.** The "desirable residence called Tor Royal House, with about 290 acres of Land half-mile from Prince Town, Dartmoor" is advertised to let. The residence itself is described as having a spacious entrance hall, dining room, drawing room, breakfast room, five best bedrooms, three servants bedrooms, two attics, kitchen, back kitchen, housekeeper's room and scullery. The outbuildings comprise two stables, loose box, coach house, harness house, "and other commodious and convenient buildings attached".

29th **1884.** The first meeting of the shareholders of the Princetown Railway Company is held in London. It is reported that, in the twenty weeks to December 31st last, the line had carried 13,000 passengers and 3-4,000 tons of freight.

The wide bend on the Yelverton to Princetown railway at Yes Tor Bottom, with the Swelltor quarries in the background (q.v. February 29th).

✳✳✳✳✳

March

1st **1752.** Edmund Williams dies and is buried at Harford. His ledger records that he had served in the Royal Navy for 50 years. (There are memorials to other naval commanders in various Dartmoor churches and churchyards, but no others to someone who had served as long ago as the reign of Queen Anne!)

2nd **1842.** The Walkhampton vestry agrees that "an Iron Chest be forthwith provided for the purpose of depositing the parish papers in". By this date it was too late to save many of the early parochial papers and ledgers which had, for many years, been stored in the damp and musty atmosphere of an old wooden chest, records which are now in such a miserable state of decay that they are today held at the Plymouth & West Devon Record Office in a file marked "unfit for production".

3rd **1733.** For a consideration, or fine, of £42, Alice Geols takes a lease on Combeshead in Walkhampton.
2000. South West Water's proposals for the redevelopment of the Burrator area are roundly defeated by the 26-member committee of the Dartmoor National Park Authority.

4th **1870.** Mr Palmer of Riddeford, Peter Tavy, wins the first prize of £1 8s (£1.40p) in a ploughing match at Horndon.

5th **1789.** In his settlement examination Richard Luscombe of Ugborough (born in South Brent) states that he was formerly an apprentice to the Reverend Walter Taylor, further saying that "the Paper by which he was bound was, as he believes, a proper Indenture, there being a Stamp and Seal on it, & it was made by John Trist, a Schoolmaster".
1956. The last passenger train, consisting of two engines and six coaches, runs on the Yelverton to Princetown line.

6th **1617.** A number of people are killed by "the fall of parte of the market house of Chagford uppon a Tin Compte daie".
1789. In his capacity as overseer of Harford, William Dunsterville, owner of Stowford Mill, signs a maintenance bond to compensate the overseers of Ugborough for maintaining Ann Willis of Harford and her illegitimate child, Harford "not being at present provided with any fit or convenient Place...for receiving and lodging the said Ann Willis and for her Lying-in". John Andrews, solicitor of

All that remains of Reddaford Farm are a few paltry wall remnants within a spacious courtyard enclosed by massive hedgebanks and cornditches (q.v. March 4th).

Modbury, drew up the bond, for which his charge was 13s 6d (67¹/₂p).

1797. Thirteen-year old John Stook is shot at Runnage, sometime between 9 and 10 o'clock in the evening.

7th **1829.** Richard Smerdon renews his lease on "All that messuage or tenement and the water grist Mills called Cocknaford [Cockingford] Bridge Mills...together with the stones tackle wheels machinery and outbuildings" for a further 12 years, the term to begin on Lady Day (March 25th) following.

1845. Thomas Spry is appointed the assistant overseer and collector of the poor rates for Whitchurch. His salary is set at just £12 per annum.

1911. It is well known that there were far more pubs and inns in towns and villages in former times than there are today. In the application for the renewal of the licence of the Commercial Inn, North Street, Ashburton, made on this day in 1911, it is stated that there are no less than seven other pubs or inns within just a hundred yards of the place! Now there are less than that number in the whole of Ashburton town centre.

8th **1817.** An advert in the *Plymouth & Dock Telegraph* offers for sale by auction Hoo Meavy House and the barton and farm of Hoo

Meavy, the property of Henry Mervyn Baylay, Esq. Included in the sale are "the dues and other beneficial interests in that promising Tin Mine, Wheal Morley, situated in the heart of the estate", for the (re)working of which a company is being formed, "with the most substantial prospects of success".

9th **1824.** Sir Manasseh M. Lopes leases the Wheal Franco Mine sett, at Horrabridge, to William Patey, John Paull and John Boswarva, with "the liberty of digging working and searching for certain Ores Minerals and Metals in and through the Lands and Limits hereinafter described". (This lease was surrendered five years later for a new one giving an extension to the limits of the sett, and a full mining grant, authorising them to "dig work mine and search for Copper and all other Ores Metals Minerals and Fossils to be found in and throughout the Lands and Premises comprized within the limits".)

1891. The Princetown to Yelverton train becomes trapped in snow-drifts. The passengers and crew are not rescued until two days later. Coincidentally, an article in the *Tavistock Gazette* ten years earlier, reporting on the "calamitous snow storm which has descended upon these islands", stated that "such a visitation does not happen twice in half a century". It was wrong!

1910. The 80th birthday of North Bovey's much-loved rector, the Reverend William H. Thornton. To celebrate the occasion, the parishioners present him with a new pulpit for the church.

10th **1691.** John Rogers, merchant of Plymouth (later of Blachford), buys from William Drake the manor, barton and mansion house of Ivybridge, seven parts of Yeo Tenement in Ugborough, plus all other lands in Harford, Cornwood, Ugborough and Ermington formerly belonging to the late John Drake of Ivybridge.

11th **1754.** The bounds of the Challacombe tin sett are cut by Henry Wheare in the presence of John Roberts Jnr and John Ponstone, tinners. The bounds are described thus in a later deed: "The Headweare is on Challacombe West Down, Higher Side Bound North on Hammelton Hill and facing Head Warren Middle Side Bounds North by the Road nr Challacomb the Lower Side Bound North in Middle Steal part of Challacombe the first Side Bound on the South is on the South Side of West Down the second on the South is on Sesson Clay the third on Sesson Common the fourth on Grendon Down and the Tail Bound is on Blackston Moor".

1985. The Dartmoor Preservation Association purchases 50 acres of land at Swincombe.

12th **1691.** William Warden is whipped as a "wandering rogue" in Whitchurch and the local justices order him to be sent back to Hertfordshire, his place of legal settlement. He does not get very far. Whilst being transported on horseback soon after the start of his long journey, in the company of two Whitchurch constables, he collapses and dies on Blackdown.

1990. Derek Newman and Caroline Atchley are married in Keble Martin's Chapel.

13th **1798.** James Mitchell of Ugborough is presented with his income tax bill for the previous year. The amount demanded is 10s 6d (52$\frac{1}{2}$p)!!

1833. John Spry and William Snell are given formal notices to quit their farms at Gnatham, Walkhampton, by Lady Day 1834.

14th **1793.** John Swete, writing in his diary about a sketch that he made of Lydford Gorge, notes that "it is impossible for the pencil to convey a notion of the horror that broods around, or the depth of the chasm; the whole, however, hath a deal of wild imagery". On the following day he visits and sketches what he calls the Lydford Cascade (the White Lady Falls) at the foot of the gorge.

15th **1768.** A note written in the Cornwood register records that there are 117 families in the parish, a total of 524 individuals.

1915. Richard Lavers, last warrener at Trowlesworthy, dies. A friend of William Crossing, he had told this well-known Dartmoor author that warrening was a hard and lonely life, and that if he had his time again he would not chose it.

16th **1883.** The body of 20-year old miner Albert E. Newcombe, killed in the Sortridge Mine accident two months previously, is recovered from an old mining adit. The body is so mutilated and decomposed that no innkeeper in Horrabridge is prepared to take it in until the coroner's inquest. (It was formerly the duty of publicans to look after bodies in villages where there was no public mortuary.)

17th **1834.** Thomas Greep and Simon Willcocks are paid the final instalment on their contract of £21 2s 1d (approx £21.10p) "for making 101$\frac{1}{2}$ yards of Hedge to inclose a Newtake on Peek Down Walkhampton". The small newtake was formed in order to provide Thomas Vogwell of Babyland a change of pasture for his stock.

1875. The hillsides around the Wheal Friendship workings fall silent, as Richard Taylor, liquidator, reports on the "Return of Winding-Up Meeting of the Wheal Friendship Company Limited".

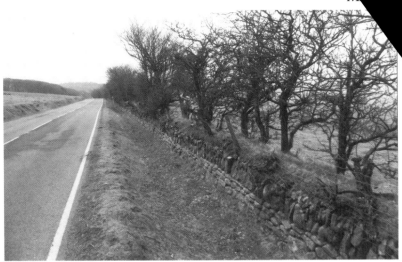

Thomas Vogwell's newtake wall beside the road on Peek Hill (q.v. March 17th).

18th **1337.** A charter creating the Duchy of Cornwall refers to "the Castle and Manor of Lydford and the Chase of Dartmoor with all its appurtenances". As far as recollection serves, this is the only legal document which the present compiler has read (in the form of a transcript/translation) which refers to the so-called 'Forest' under its correct title. (The Forest of Dartmoor is, in strict conformity, a chase.)

19th **1901.** Nancy Pearse, widow of John (who died in 1893), is buried at Walkhampton, aged 91. Hers is the last headstone to be erected in the oldest plot of the churchyard, closed to future burials in 1874, for the couple had been deemed a special case and given permission to be buried in the old plot alongside the graves of their children.

20th **1627.** For "the some of one hundred and ffortie poundes of lawfull money of England" Sir Francis Drake grants a reversionary lease on Weymington and Downe House in Sampford Spiney to Thomas Dyer, the term to begin "imediately after the expiracon or other lawfull determination of one lease...nowe in being...made by Thomas Drake Esqr father of the said Sir ffrancis Drake unto one Thomas Toser".

1679. Josias Foote of Walkhampton lets Willsworthie in Peter Tavy to Walter Cole.

ip Andrews of Harberton agrees to serve as a substitute
Dodderidge of Ugborough, who had been drawn by
ˑve in the militia. (This is fortuitous, for present-day
.vould not otherwise have been able to find out much
ˌ Tobias Dodderidge or his work. He was, in fact, a
blacksmith, and after 1780 presented many dozens of itemised
bills to the Ugborough highway surveyors, overseers and
churchwardens, dockets which provide a valuable insight into the
wide variety of tasks which contemporary village blacksmiths
everywhere were called upon to undertake for the parish officers.
Tobias died in 1816, and his headstone may still be seen in the
churchyard at Ugborough, alongside those in memory of his wife
and some of their children.)

1806. The building of the war prison at Princetown commences.

21st **1673.** Sir William Strode of Newingham grants a reversionary
interest in South Truelove in Shaugh Prior, with commonable
rights "upon the East wast of ffernehill called Crownehill Downe
and upon the north wast...called the Pitt and Wideslake moore", to
his son, Charles, "for the naturall love and affection which hee
hath and beareth unto the said Charles Strode and for his better
support and livelyhood".

1850. In one of many and frequent purchases in the early 1850s,
the captain of the East Birch Torr Mine buys 732ft of timber from
the woodlands at Buckland-in-the-Moor for 6d (2$^{1}/_{2}$p) per foot. The
difficulties of hauling such vast quantities over unmetalled tracks
and rough terrain can scarcely be imagined.

22nd **1641.** Richard Adames the elder of Sampford Spineye assigns "the
two higher bowtownes the smaller pke and meadowe called the
ald womans meadowe and the litell howse att the bakes end all
wch are pte and pcell of a messuage and tenement called Don als
By the Downe" to John Langforde and Nicholas Reede as part of
the marriage settlement following the marriage of his son, Richard,
to Unity Langford.

1794. A Mr Parson of Buckland Monachorum forfeits 5s (25p) to
James M. Heywood "in lieu of a Cart Wheel which became
Deodand by killing George Bowhay at Horrabridge in November
last". (A deodand was any moveable object or animal which
caused the death of a person, the offending object or beast being
forfeit to the lord of the manor. The custom was abolished by Act
of Parliament in 1846.)

1888. Robert Burnard reads his first paper to the Plymouth

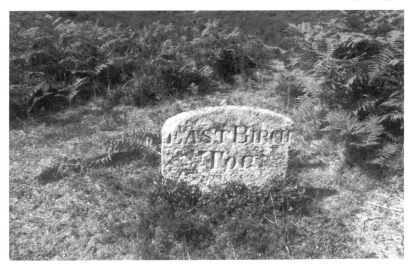

The East Birch Tor boundary stone is the only one on Dartmoor upon which is inscribed the name of a mine (q.v. March 21st).

Institution, on the subject of tin streamworks on Dartmoor.

23rd **1890.** J. F. Clarke, vicar, and William Jackman and John Tucker, churchwardens, write out a new list of 'The Charities of South Tawton'. The wooden board bearing these details still hangs in South Tawton Church to this day.

24th **1650.** Under the "Act for Abolishing Deans & Chapters, Canons, Prebends [etc]", the South Tawton properties belonging to the Dean & Chapter of Windsor, comprising "three cottages scituate neere South Tawton churche", plus various plots of land totalling about 48 acres in extent, are sold for £374.

25th **1444.** John Gylle of Downhous grants his land at Waymeton and Pytherhille (Whimington and Pethill) in Sampfordspynea to Roger Hilman and his wife Gillian.

1635. For £300 Richard and John Adams of Sampford Spyney sell "All those their Messuages Lands Tenemts...called or knowne by the names of Don alias Downe lyinge and being in...Sampford Spyney" to William Peterfield, a tinner of Walkhampton. The property later became known as 'By the Down'.

1639. Anne Hill of Widecombe, widow of the Roger Hill who was killed in the Great Storm of 1638, assigns her interest in Woode in Widecombe to her son, Richard, "for the naturall love and Affection which she bareth to the saide Richard Hill".

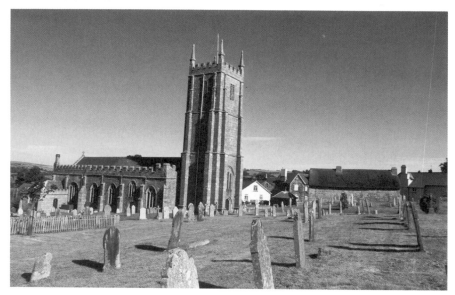

St Andrew's Church, South Tawton (q.v. March 24th).

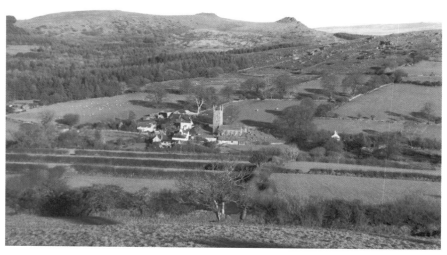

Looking across the Jobbers Fields on the flank of Ringmoor Down to the village of Sheepstor, with Peek Hill, Sharpitor and Lether Tor on the skyline (q.v. March 25th).

1898. The fields called 'Jobbers' in Sheepstor (a narrow strip of enclosures at the foot of Ringmoor Down) are let by the Maristow Estate to Richard G. Legassicke.

26th **1629.** An inventory of the goods of Edward Northmore, late of South Tawton, includes references to a number of mysterious items. Amongst them are a messe of pewter, a goosepann, a paire of pott crooks and a wembshett with baggs & seves. His assets in livestock are described as comprising 6 keyne (cows), 3 yearelings, 5 younge bullocks, 41 sheepp, 1 nagg and 3 pigges.

1666. John Drake Esq of Ivibridge lets Badge's Tenement in Sampford Spiney "bounded on the west side by the footpath that Leadeath from Hockery Bridge to Sampford Church and on the east side by the Kinges Highway that Leadeath from the said Bridge to Tavistocke" to Peter Badge of Sampford Spiney.

27th **1825.** John Giles, carpenter, and John Folland, mason, receive payment of the final balance of their bill of £155 for "Building new Dwelling House & Repairing Outhouses at Ditsworthy Warren".

28th **1328.** Bishop Grandisson's register records that this is the day upon which monk Richard de Middlecote maltreated Agnes, daughter of Richard the Miller, and murdered her child, in the little Chapel of La Wallen, Gidleigh. He was later charged with these offences, but escaped punishment by claiming benefit of clergy.

1995. Strong winds blow the face off the clock on the tower of Ugborough Church.

29th **1654.** William Soper is appointed register – not registrar! – of Mary Tavy. The appointment is made by John Elforde, JP.

30th **1801.** Joan Tremills is buried in Widecombe, her burial entry in the register recording that she "died in Walkhampton". This suggests that she was probably visiting her cousin at the time, William Stockman of Buckland Monachorum (formerly of Widecombe), who held the lease on Merrivale Farm and also the newtake straddling the Walkhampton/Whitchurch parish boundary. For, in a rather convoluted series of relationships, she was the sister of Martha Tremills, who had married John Smerdon Jnr, the son of John Smerdon Snr and Joan Stockman, sister of William.

31st **1816.** Granby Russell of Walkhampton buys 462ft of beech from the Knowle Plantation at a total cost of £51 19s 6d (2s 3d – just over 11p – per foot).

1894. The newly-formed Dartmoor Exploration Committee's excavation of Grimspound begins, under the supervision of the Reverend S. Baring-Gould and Richard H. Worth.

1895. The Plymouth Corporation publishes its annual accounts. One of the biggest – if not *the* biggest – items of expenditure is that for the wages to the workmen during the building of Burrator Dam, which amounts to £10,832 18s 7d.

✳✳✳✳✳

April

1st **1880.** In a reference to part of what is now the stoney track called Norsworthy Lane, but was hitherto one of the main 'roads' of the district, leading to the way across the commons, the Walkhampton vestrymen agree that "the portion of road between Kingsett Gate and Cockle's Gate should be repaired at the expense of the parish".

1910. An entry in the Harford vestry minutes reports that the rector had found an old wayside cross "doing duty as a gate post in the Sanctuary Glebe-land". This "most interesting parochial event" (as described in the minutes) was later reported in the local press, and the cross itself was re-erected in the churchyard, where it still stands to this day.

2nd **1863.** I wonder how many young Dartmoor men and women responded to this advert, printed in the *Tavistock Gazette* on this day? – "Assisted Emigration to New Zealand. The provincial Government of Southland (formerly part of Otago) will give Assisted Passages to a limited number of Farm labourers, Shepherds, and Female Domestic Servants. The next ship will leave London on 10th October".

3rd **1683.** Thomas and William Baron sign a bond agreeing to indemnify the overseers of Ugborough "from all manner of Costs Charges & expences whatsoever which shall or may in any manner or wise at any time hereafter arise happen come grow or be imposed upon them" for maintaining a bastard child recently born to Honor Baron.

4th **1583.** The will of Nicholas Slaninge includes mention of a tin mill at Heckworthie, Walkhampton, tenanted by Thomas Odimer alias Clarke, and fulling and corn mills in Prior Shaghe tenanted by Johan Foote, widow.

1750. "The fee Simple and Inheritance of the Manor of Sheepstor, and the Capital Messuage, Barton and Farm, called Longstone, with the Rectories impropriate and Sheafs of the Parishes of Walkhampton and Sheepstor, and divers Messuages, Lands and tenements, lying in the said Parishes of Walkhampton and Sheepstor, and in the Parishes of Meavy and Buckland Monachorum" (as described in contemporary bill posters and

The former wayside cross in Harford churchyard, found in 1910 "doing duty as a gate post" (q.v. April 1st).

press adverts) are offered for sale by auction by trustees – three years after the death of the last of the Elfords, who were lords of the manor of Sheepstor.

1878. The rural dean draws the attention of the churchwardens of Shaugh Prior to "the propriety of restoring the canopy to the Font which is now in a private house. It is a singularly beautiful one, and the proper fixing of it would cost but a trifle". It was later rescued from the barn of the house in question and is now the outstanding feature of the church interior.

5th **1603.** An inquisition post mortem taken following the death of Stephen Addam of Buckfastleigh refers to "the fifth part of two messuages one garden ten acres of arable meadow and pasture in Sulebar in Mevy". Other documents also refer to this tenement in Meavy, more commonly spelt Shillabeer (or similar variants), the precise location of which presents something of a mystery.

1818. In his will William Stidston of Dean Prior leaves £100 to the parish, "the interest of the same to be laid out forever in bread half-yearly to be distributed among the industrious poor not receiving parish pay".

1889. The north-east pinnacle of Walkhampton Church is struck by lightning and sent crashing through the roof of the nave.

6th **1663.** William Eustis, John Cowch and Agnes Richards mortgage South Godsworthy in Petertavye to Andrew Whiddon of North Bovey.

1835. Samuel Skelton is appointed assistant overseer and vestry clerk of Buckland Monachorum at £25 per annum. Amongst his duties is a requirement for him "to remove all paupers to their Place of Settlement".

1920. An oak tablet recording the names of those who had served in the Great War is presented to Harford Church by Barbara MacAndrew of Lukesland, widow of James J. MacAndrew. She also gives peace mugs to all children of the parish under 15 years of age.

7th **1924.** Advert in the 'To Let' columns of the *Western Morning News*: "Postbridge: Furnished Caravan, 3 bunks from 2$\frac{1}{2}$ guineas [£2.62$\frac{1}{2}$p], 30s [£1.50p] for 6 months; Bourchier, Woodwater, Exeter".

8th **1849.** Isaac and Sarah Gould of Tavistock set sail for Australia with their eight children on board the *Prince Regent*. The voyage from Plymouth was to take them more than three months (they eventually arrived in Adelaide on 20th July), during which time a ninth child was born to the couple. Named after the captain of the

ship, baby Walter Jago Gould died shortly afterwards and was buried at sea.

9th **1613.** William Bourchier, Earl of Bath, lets "all that waste ground called Spitchwick Common...with free liberty to make a warren there for the keeping and breeding and killing of rabbits" to Richard Reynell and Walter Fursland.

1882. George Degorie Gray Seccombe is born in St Clements, Norfolk. He was baptised in Meavy later the same year.

10th **1699.** James Cole and John Williams give to Mary Tavy Church "a messuage or parcel of land...called Shortditch, two parcels of land lying in East Holstone, and one parcel of land called West Holstone in the parish of Lydford, together also with one parcel of land called Mary Island in the parish of Mary Tavy".

11th **1740.** Abraham Giles of Walkhampton is appointed herdsman, or prior, for the western quarter of the Forest of Dartmoor.

1794. Some items bequeathed by John Pearse of Filham, Ugborough, to his son of the same name suggest that he was a surveyor by profession – "such of my Books Globes Surveying and Leveling Instruments as he may choose". He also leaves his son, John, all of his timber boards, except, rather curiously, those of cherry and yew, which latter he leaves to his other son, Joseph.

12th **1759.** In an enquiry into the Roperidge Charity, the Ugborough Workhouse Committee learn that "upon Examining of Mary Lang a poor person of this parish Aged about ninety years and other Antient people we find by them that the said Charity was paid about Thirty Years since by the Representatives of the said Sir John Fowell But since that time it cannot be ascertained which field called the Roperidge and the other Lands of Fowlescombe are now the property of Francis Drew of Grange in this County Esquire, who is desirous to have the Charity Settled".

13th **2000.** An exhibition entitled 'Dartmoor Century' is opened at the High Moorland Visitor Centre, featuring late-Victorian Dartmoor photographs, taken by Robert Burnard, alongside contemporary photographs of the same scenes, to show how much, or how little, the locations had changed. Two days later the exhibition is officially opened to the public, when the book of the same title, produced by the Dartmoor Trust, is also released.

14th **1857.** Ormerod reports seeing a cross shaft in use as a gatepost in a field near Watching Place Cross, North Bovey. It was later rescued and re-erected in its present position at the nearby junction, and has since become known as Beetor Cross.

The silent sentinel at Watching Place Cross (q.v. April 14th).

15th **1852.** Handbills had previously been circulated around the district informing prospective clients that on this day Richard Toop, auctioneer, will offer for sale Cole's Tenement in Horrabridge, a property stated to be "driven by a water wheel". What, precisely, the premises comprised, or where exactly it was situated, is not clear from the surviving documentary evidence.

1870. The *Tavistock Gazette* announces the issuing of a "neat shilling edition" of N. T. Carrington's *Dartmoor*, also observing that "the time is approaching when Dartmoor will be accessible to the excursionist". I wonder what the reporter would have said had someone suggested to him that a little over a century later Dartmoor would be visited by millions of "excursionists" every year?!

16th **1851.** A total of 200 mature oaks are sold at the annual spring standing timber and coppice sale at Buckland-in-the-Moor. Amongst the purchasers are Richard Routly of Scorraton, who buys 25 oaks in Woodley's Wood for £15, and Elias Barter, carpenter of Holne, who buys 23 oaks at Warren's Bridge for £20.

17th **1743.** Mary Whitchurch is baptised in the parish of that name. She is given the surname of the parish for she is "a Child left at ye door of ye Tenant at Sortridge her Parents unknown".

1815. "On ascending the fatal drop his false courage forsook him, he appeared dreadfully agitated, and met his fate with fear and trembling". So reads the final sentence of a short article in the *Plymouth & Dock Telegraph*, reporting on the execution of Samuel Norton on this day for the brutal murder of Mary Metters at Bughill, Whitchurch. The headstone to the victim, which also names her murderer, still stands in the graveyard at Whitchurch.

1831. John Berry, sergemaker, becomes the new owner of Tozer's House in East Street, Ashburton. His borough rent for the property will be 10d (approx 4½p) per annum.

18th **1793.** Christopher Lethbridge of Ermington and John Tucker of Ugborough are summoned to attend a magistrates court at Sackersbridge "to shew cause why each of them shall not take a parish Apprentice".

19th **1789.** Under the standard licensing requirements of the day, the constables of Ugborough are ordered to present the local innkeepers before the justices in order to renew their licences. Each is required to bring a certificate signed by some respectable parishioners, to the effect that he is of "good fame and sober life and conversation". One of the innkeepers in the parish at the time

happens to be the appositely-named John Beare. In spite of his name, however, there was probably no doubting his "good fame" etc, for he also served as parish clerk for nearly 30 years.

1886. John Andrews of Buckland-in-the-Moor receives his wages for having cut down 4,404ft of oak and 2,409ft of larch. How long it had taken him to perform these tasks is not known for certain, but the plantation workers were normally paid fortnightly during this period. His wages work out at 4s 6d (22^1/2p) per hundred feet.

20th **1579.** In his will William Wreford of Ashburton leaves his shares in tinworks called Wellysfourd, Allerbrook and Moor Parke Head to his son, John.

21st **1789.** John Ryder is arrested for stealing some chickens from James Mitchell of Ugborough. As is frequently the case in instances of petty theft, the expenses in bringing the charges far outweigh the value of the items stolen. In this instance William Prowse, parish constable, had to search the neighbouring parishes in order to find John Ryder, two other locals were employed as guardsmen to assist in taking him to Exeter gaol, four horses had to be hired for the journey, the costs of board and lodgings (and provisions for the horses) had to be met, and another constable, John Chrispin, was also reimbursed for his (unitemised) expenses relating to the case. In fact, the costs of bringing the suit were at least £5: the chickens, on the other hand, were valued at just 1s (5p) each!

1938. A new Sunday School room is opened at Dunstone Methodist Church, Widecombe.

22nd **1823.** By now privately-owned banks were issuing their own notes. An intriguing entry on this date in the debit columns of the Maristow stewards' accounts suggests that some mines were also doing so: "Seven One Pound Ailsborough Blowing House Notes sent to you [Sir Ralph Lopes] at London: £7".

23rd **1593.** Peter Windiatt of Buckland-in-the-Moor and Adam Coplestone of Aisburton swear on oath to a Buckland manor court as to the names of the ancient bondmarks on the commons of Buckland.

24th **1591.** Sir Francis Drake rides triumphantly into the outskirts of Plymouth at the head of the first cascade of water flowing down the newly-opened Plymouth, or Drake's, Leat. At least, that is what legend, or folklore, contends, although whether this is a factual account of what happened has been disputed by historians.

1789. James Lyde and William Prowse are appointed overseers of the poor for Ugborough.

1808. Jane Adams' bastard daughter, Sarah, is baptised in Cornwood and, as the register records, "...the mother was permitted to be delivered in this parish under an engagement that Plympton would consider the child as belonging to that parish". A similarly phrased clause is recorded against the baptism of her son, John, (also in Cornwood) two years later.

25th **1750.** A racing 'match', the best of three heats between two mares, is held on Roborough Down at 3 o'clock in the afternoon. The prize is 100 guineas (£105). Unfortunately, no surviving source appears to contain a record of the name of the winner!

26th **1689.** At a Buckland-in-the-Moor manor court, the occupiers of Bohaydown and Elletts Hill (Bowden and Elliott's Hill) are ordered to repair the Liddygate, upon pain of forfeiting 10s (50p) if they fail to do so before the court sits again. The gate is that at the head of Bowden Lane, which is now known as Ripman's Gate.
1867. Sir Massey Lopes buys 5/6ths of Knowle in Walkhampton for £2,800. The premises are described thus in the deed of sale: "All those five undivided sixth parts or shares of and in All that Messuage Barton and Farm called by the name of Knowle... containing by estimation One hundred and nine acres".

27th **1750.** From the Ugborough Workhouse Committee minutes: "This Day made an agreement with Eleanor Stidstone for the Sum of ffour pounds & ffour shillings [£4.20p] to carry herself and three children to Ireland and their maintenance for the future so that the parishioners are to hear no more of them".
1791. The Awsewell Mine sett is leased to Christopher Gullett, who is also granted "free Liberty and Licence of making building and erecting the Stamping Mill and Mills in and upon the old and same usual Place and Places as have been done heretofore".
2000. The DNPA formally announces that, after many years of negotiation, and recent reconstruction work, a new section of the Lich Way through Gawler Bottom is finally open to the public. This re-routes the path from its former supposed course through the middle of a swamp near Higher Cherrybrook Bridge, which made the ancient "Way" virtually impassable to wayfarers!

28th **1837.** Edward Hurrell, mason of Shaugh Prior, is asked to make "18 mowstead posts 3ft 6in long and 18 caps 20in in diameter" for Roborough Farm. (Mowsteads and caps of this type were what are now usually known as staddle stones and their 'mushroom' tops.)
1934. Bill posters are circulated by Woollcombe & Jago advertising for sale by auction at the Royal Hotel, Plymouth, "A valuable

The new gate leading to the revised route of the Lich Way through Gawler Bottom, beside the Postbridge – Two Bridges road (q.v. April 27th).

Freehold Estate called Hoo Meavy...consisting of a Dwelling-House...Coach House, Stabling, and other Offices and Farm Buildings".

29th **1662.** The churchwardens of Tavistock raise £2 6s 3d (approx £2.31p) from the parishioners "for & towards the expence & charge of one Eliseus Cruse of this place in travelling to London to bee touched by the Kings Maiestie for the Kings Evill". (The King's Evil was the disease medically known as scrofula.)

1774. Jacob Fynes, rector of Moreton, dies. He poses a conundrum which the present author has been unable to resolve, for his family name was, in fact, Clinton (which he changed because of the Jacobite connections of that family). Research suggests that he might well have been the rightful heir to the barony of Clinton in Lincolnshire, which was claimed by Hugh Fortescue in 1721 and subsequently passed, by marriage, through a number of other Devonian families. The line of inheritance during this period is greatly perplexed, so much so that the right of the claimants of the new line was not even recognised in law until as late as 1794.

1833. The cottage at Gee's Cross on Ringmore Down is let to Miss Fanny Smith and her sister, Mrs Andrews, for 2s 6d (12$\frac{1}{2}$p) per month. Intended to be a temporary let, it appears that the pair

overstayed their welcome and were still in residence – and in arrears with the rent! – some two years later.

30th **1845.** The Tithe Commissioners divide Pewtor Common between Sampford Spiney and Whitchurch, order new boundstones to be erected and create the narrow strip of land, belonging to Sampford Spiney, now known as the Ace of Diamonds.

Sampford Spiney boundary stones in Beckamoor Combe, at the northern end of the piece of ground known as the Ace of Diamonds (q.v. April 30th).

❋❋❋❋❋

May

1st **1833.** The Buckland Monachorum vestry minutes record that "Lady Moddiford's Endowed School was resumed by Sir Massey Lopes Bart. in consequence of the Trustees allowing the said School to get into a state of delapidation".

1994. The final service takes place at St Michael's, Princetown.

2nd **1791.** Betty Keagle is buried at Buckland Monachorum. Typically for the period, the register entry makes no mention of the cause of death. But her headstone reveals that the reason was the dreaded "pale consumption", also known as the white plague – pulmonary tuberculosis.

1964. Demolition work begins at another Dartmoor site. All that now remains of Foggintor School are the walls of its grounds, old photographs and memories.

3rd **1779.** In his will James Elliott of Ashburton, thatcher, leaves "all the messuage and orchard in Bowden Hill" to his son, Benjamin, and "the leashold of two dwellings & herbgardens in Bowden Hill formerly called Hunts Cottages" to his other sons, Charles and Joseph.

4th **1745.** The Reverend Thomas Burnaford of Lydford is buried. A note against his burial entry records that he "moontain'd a long & expensive Suite wth ye moore men for the recovery of ye rights of his church and at length obtain'd a Decree for ye future payment of great & small Tythes out of ye Forest as well as a recompense for unjust detenshion".

1837. Two new boundary stones are erected during a view of the bounds of the manor of Buckland-in-the-Moor.

5th **1754.** The husband-and-wife partnership of Philip and Rebecca Rogers takes over as managers of the Ugborough workhouse. Their renumeration is just £10 per annum.

6th **1829.** John Giles and William Blowey receive an advance payment of £50 on their contract for "Building a Cottage on Ringmore Down near the Gate of Brisworthy Green".

2000. Emma Wills is crowned Lustleigh May Queen on a brand new granite throne atop Town Orchard Rock, on the edge of the village. The new throne was designed by local architect Doug Cooper to celebrate the new millennium, and was made at

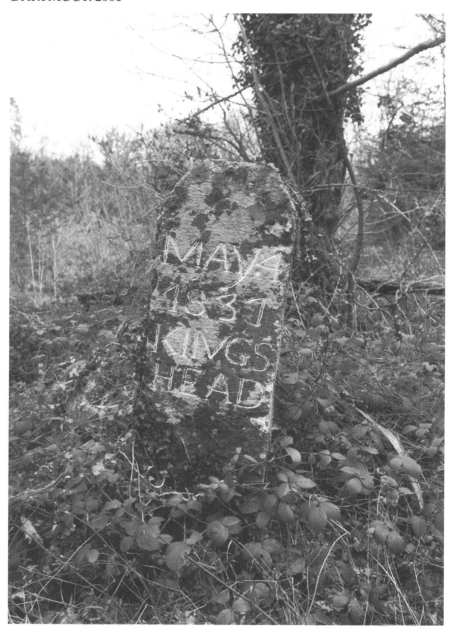

The King's Head boundstone at Buckland-in-the-Moor (q.v. May 4th).

Blackingstone Quarry by master stonemason Warren Pappas.

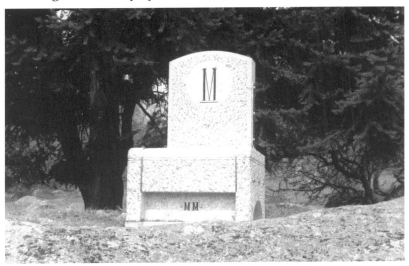

The new Lustleigh May Queen throne, a fine example of superb crafts-manship by master stonemason Warren Pappas (q.v. May 6th).

7th **1565.** The heriot of an ox is paid to the lord of the manor upon the death of John Bennett of Criptor in Walkhampton. Richard, eldest son of John Dunyng, and Mary, daughter of Robert Hannaford of Tamerton, are admitted as the new tenants at the farm.

1745. A terrier records that the Parsonage House at Belstone comprises "seven Rooms a Parlour and four Chambers floored with oak & deall a Kitchen with Lyme & sand & a Cellar with stone none of the rooms wainscoted by all ceiled & washt with lime except ye Cellar & one chamber ye house is covered with reed".

1870. Closing his report on Wheal Yeoland Mine, dated this day, Captain Joseph Eddy of Bottle Hill Mine writes "I do not hesitate to say that if water can be obtained for working stamping mills and other machinery necessary for mining purposes this is a valuable property for mining more especially if Tin retains its present value".

8th **1589.** Henry Toll of Sourton is presented at the Lydford (Forest of Dartmoor) court for allowing the "newe wall between the Commons of Sourton and the Forest of Dartmore" to be ruinous. This is just one of many dozens of presentments against Henry

Toll during Elizabethan times, other sites for which he was responsible being Sowtherley Yeat, Luden Combe Hedge or Wall, Neuton Combe Hedge and the "Newe Wall" at Sutherley. Of course, as Sourton itself lay outside the jurisdiction of the Lydford courts, Henry Toll never repaired any of these places, and did not even acknowledge the presentments, or pay any of the fines imposed upon him! Remarkably, the same presentment against the same personal name appears in the rolls as early as 1538 and as late as 1609 – presumably denoting a father and son of the same name.

1780. A bill of this date indicates the vast quantities of materials which were formerly hauled around Dartmoor as a matter of course, by methods which, nowadays, would be regarded as very primitive. To repair just a short stretch of road on the foothills of Dartmoor, Yeoland Brook Lane, requires the remarkable quantity of 449 seams (packhorse loads) of stones. Even more remarkable, perhaps, is the cost of the labour involved. In his itemised bill John Soper claims £1 17s 5d (approx £1.87p) for all his hard work – just one (old) penny per load!

1995. Six pine trees are planted in Lydford churchyard to commemorate the 50th anniversary of V.E. Day. A number of other Dartmoor parishes light beacons to mark the occasion.

9th **1919.** The new parish of St Michael & All Angels, Princetown, is created, taking in a large chunk of the Walkhampton Commons from Devil's Bridge, through King's Tor, up to Merrivale Bridge.

10th **1254.** William le Pruz of Gideleghe pays Fulk de Ferrariis 50 marks of silver for a moiety of a knight's fee and the advowson of the church in the township of Throuleghe.

11th **1675.** Richard Bennett sells Lower Puttisham in Buckland-in-the-Moor to Elize Andrews for £200.

1833. At an Ugborough vestry, the parishioners agree to give James Hole £35 to enable him and his family to emigrate to America.

1993. A new stone on the Ilsington bounds, inscribed 'Duke Stone/DS 1853 FHS', is erected as a tribute to the late F. H. (Harry) Starkey. It replaces a stone on the old Natsworthy Manor bounds (to which the first set of initials – Duke of Somerset – and date refer) swept away by a flood in 1936.

12th **1755.** Sir Frederic L. Rogers of Blachford attends "the Court Baron of his Majesty King George the second Lord of the Manor & fforest...held at the Castle of Lydford...before Benjamin

Eastabrooke Gent Deputy Steward..." (as described in the contemporary manor court rolls). The reason for his presence is an interest in the copyhold of the ancient tenements at Babeny.

1765. Peekmill clapper bridge is repaired at a cost of £6 17s 7d (approx £6.88p). (The work had taken five labourers about six weeks to complete; the final bills for the labour were presented on this date; the total does not include the cost of any materials.)

1866. Thomas Wotton, Benjamin German, Silas Pike, Henry Thomas, Henry and John Fox, and a young boy named Michael Yeo are killed in the Furze Hill Mine disaster. The accident occurs when the Foxes, father and son, working at 40 fathoms below the surface, unwittingly pierce a hitherto unrecorded level dug out by the 'old men'. Water pours in through the breach, flooding the mine up to the 30-fathom level within minutes.

1880. Three hundred and eighty-seven rabbits sold at Ashburton market fetch a total of £16 2s 6d (£16.12^{1}/2p).

13th **1672.** Richard Shebbear of Okehampton records in his journal that on this day "Mr Mayor, with many inhabitants of this town...viewed the bounds of Dartmoor Commons belonging to this Parish".

1859. The *Tavistock Gazette* reports on a "dreadful and fatal accident on the Cornwall Railway". The headstone to William Hosking, train guard, one of the three railway personnel killed in the accident, still stands in South Brent churchyard.

1950. *The Mid-Devon Advertiser* reports that "The destruction of the famous Logan Stone, known as the Nutcracker, in Lustleigh Cleave, has caused indignation throughout Devonshire and, indeed, in many parts of the world".

14th **1914.** The body of widow Clara Kistle is found at The Ockery by one of her five children. At the later inquest it was found that she had taken arsenic and "committed suicide whilst temporarily insane", so she was interred without burial rites at Princetown. The absence of burial rites for a suicide did not, however, preclude rights to a memorial, and her headstone still stands in the graveyard there.

15th **1735.** Pascho Nute of Buckland Monachorum is killed in an accident. His epitaph provides what is probably the only surviving 'written' record of the cause of death, observing that "Twas my bad fortain to be drownd When ye waters did me serround".

1802. From the diary of Silvester Treleaven of Moretonhampstead: "This day pursuant to his sentence at the last Exeter Assizes,

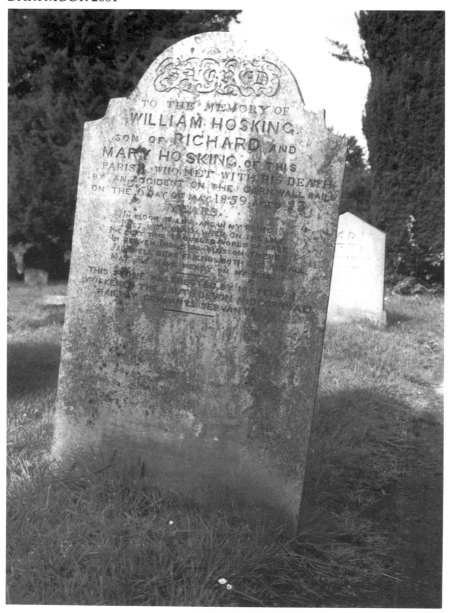

The headstone to William Hosking, in the churchyard of St Petroc's, South Brent (q.v. May 13th).

James Bird was publickly whipped, from the Corn Market to the bottom of the Shambles, for assualting James Holman of Drewsteignton on the Highway, and taking from him a hat".

16th **1695.** Thomas Hamlyn sells Higher Cator to Nicholas Leaman and Henry French. As was the convention of the period, the purchasers are first put in possession of the property by the issuing of what is known as a lease for a year. This was merely a legal conformity, with only a token rent, often a peppercorn – hence the well-known phrase – but in the case of the Higher Cator deed, a single penny "if lawfully demanded".

1902. The bounds of the Spitchwick Manor are perambulated, an event which occasions a swift rebuke from the steward of neighbouring Buckland-in-the-Moor over Spitchwick's claims to rights over the whole of the River Dart, on the manorial boundary – "Mr Bastard [lord of the manor of Buckland] desires me at once to inform you that he entirely repudiates such a claim...when the Ordnance map was made some years ago...Mr Bastard substantiated his claim which rights up to that time had been undisputed and have not since been called into question".

2000. An embroidery sampler, made in 1818 by 13-year old Susanna Maunder of Peter Tavy in memory of her baby brother, sells for £680 at a London auction.

17th **1843.** Richard Andrews of Walkhampton is allowed £1 10s (£1.50p) rebate on his rent for "filling a hole in his Meadow at Deancombe occasioned by the collapsing of an old Mining Adit".

18th **1204.** A charter disafforesting the county of Devon "up to the metes of the ancient regards of Dartmoor and Exmoor" is signed at Winchester. The charter confirms to the freeholders of Devon "the customs within the regards of Dartmoor and Exmoor as they were accustomed to have in the time of King Henry I".

1735. As part of Margaret Ponsford's covenants upon taking on the lease of West Netherton, Drewsteignton, she agrees to "permit and suffer the tenant that shall dwell in East Netherton...to rid or cleanse the water leate and to have the water coming from the lords well through powne mead".

1812. From the Buckland Monachorum registers: "Oliver Palmer aged 31 years was buried, wilfully murderd with a potatoe ax by his brother in law Jn Jutsome a Lad 17 years of age". The headstone to the unfortunate victim stands near the rear gate to the churchyard.

19th **1924.** Silence reigns in the usually noisy classroom in the little

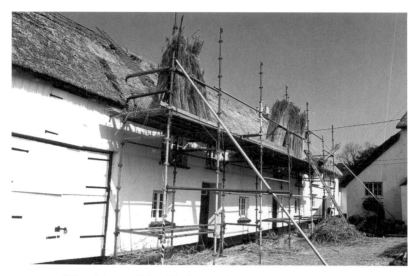

Thatching at West Netherton in 1995 (q.v. May 18th).

school at Hillbridge, Peter Tavy – not because the children are particularly well-behaved today, but because there are none! The school had been closed on the previous day due to the dwindling number of pupils. (It had a short renewed lease of life between 1941 and 1946, when it was reopened to cater for evacuee schoolchildren.)

20th **1859.** A Mr Collings of North Bovey, miller, has a serious accident whilst descending the steep hill at Druid, Ashburton, with a heavily-laden wagon. The shaft horse, one of three pulling the wagon, is so seriously injured that it has to be killed on the spot.

1870. Six-year old Charlotte Webb of Postbridge dies of poisoning after having eaten hemlock whilst playing by the river.

2000. A new stone on the North Bovey parish bounds is unveiled by Tom Pollard, representing North Bovey, and Rosemary Mudge, representing Lydford (Forest of Dartmoor). The new stone, standing on the left bank of the Wallabrook at the north-western corner of the Soussons Plantation, is inscribed 'NB/M/DF' on the relevant faces that point towards the parishes which meet at the spot (North Bovey/Manaton/ Dartmoor Forest), and '2000' on the other face.

21st **1623.** Edmond Foale of Widecombe sells "all and singular that messuage & tenement...commonly called or knowen by the name

The new North Bovey boundstone is unveiled by Tom Pollard and Rosemary Mudge (q.v. May 20th).

of Tonehill alias Tunhill situate lying and being within the parish of Withecombe" to Richard Smerdon for £52.

22nd 1775. A line in the epitaph to Mary Damerell, schoolteacher of Shaugh Prior, suggests that the unknown mason who inscribed the verse was not one of her pupils! – "And now my schoolers and my friends I leave you all behind".

23rd 1692. John Giles and Quintin Brown are Nicholas Slanning's undertenants for the Forest of Dartmoor. On this day they pay him an instalment of £20 on their annual rental of £80.

1727. The Reverend Henry Pengelly is instituted vicar of Whitchurch, thereby ceding the rectorship of Mary Tavy, where he had been the minister since 1714. Later members of the family were also vicars of Whitchurch, where a number of them are buried. The former residence of the Pengellys, Sortridge Manor, was put on the market in 2000 for a price which the rectors and vicars of yesteryear could hardly have imagined in their wildest dreams – the purchasers in 2000 would have very little change from a cool £1 million!

1873. Grace Giles of Tavistock, aged 47, is the first to be buried in the new extension of the Walkhampton churchyard.

1895. James Perrott, who in 1854 established the first receptacle for visitors' cards (letterbox) at Cranmere Pool, dies and is later buried in Chagford churchyard.

24th **1925.** Matilda Lasky of Exeter writes to the minister of Princetown for a copy of her baptism entry, because "I am applying for my old age pension an I have got to get all information I can...if you could Sir find me any Information that may help me and I know I am over 70 years old an my Husband is 73 years an we would be thankful to get the pension". Unfortunately for Matilda Lasky, it is doubtful that any useful information was forthcoming, for recent research has failed to uncover any baptism entry in her maiden name of Matilda Trebble.

1941. The nation listens in stunned silence and disbelief to the evening news on the radio as the Admiralty reports the loss of *HMS Hood* with all hands (later it becomes known that there are three survivors from the ship's company of around 1,500 men). In the church at Yelverton is a discreet epigram, within a gilt frame, commemorating Commander Donovan C. Roe, one of those killed. His name is recorded in this book in recognition of *all* of the Dartmoor servicemen and servicewomen who gave their lives for their country in the two global wars of the last century, and in other conflicts around the world before and since. And as a *reminder* of their sacrifice, so that the final line of the poignant little epigram at Yelverton will still ring true, "Their Works do Follow Them".

25th **1657.** Richard Maddocke of Walkhampton lets "all those Messuages Landes Tenemts Meadowes...scituate lyeinge & being in Abbottisayche [Aish] within the parish of South Brent" to John Stidston of Coringdon at an annual rent of 15s (75p).

1735. Instructed to bid a fond adieu to the surviving family of Henry Endicott of Throwleigh, buried on this day, an unknown mason instead inscribes these words on his headstone: "So I bead a doo to my kind father and mother and deare brothers and sisters".

1870. At an inquest held at Roborough police court, Mary Ann Trewin, of the Tavistock Union workhouse, is charged with the murder of her newly-born infant, whose body was found beside the Devonport Leat on Roborough Down a week earlier. She is committed to the bridewell to await trial at the Exeter assizes.

26th **1726.** In a long-running suit, which began in 1723, Dame Mary Rogers of Blachford, Cornwood, is convicted by the archdeacons' court of Totnes for interfering with services at Cornwood Church and ordered to pay a fine. This was not, however, the end of the matter, and it passed through successively higher courts until the

judgment was finally overturned in 1731. The cause of eight long years of litigation was an argument over hat pegs!

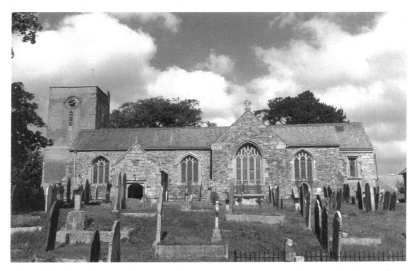

St Michael's Church, Cornwood, scene of a long-running and acrimonious dispute in the 1720s (q.v. May 26th).

1806. Thomas Michelmore becomes the Duchy's new tenant at Huntingdon Warren. The annual rent for the 585 acres of land, together with the dwelling house, outbuildings and all appurtenances etc, is £4 7s 8d (approx £4.38p).

1818. John Prior of Blackdown is killed by a gunpowder explosion at Wheal Friendship.

1864. John Martin agrees to build a bridge over Criptor Water in Walkhampton for £6 10s (£6.50p). As part of his contract he is to complete the work by 24th June "or Forfit one Sovreign".

2000. To celebrate two thousand years of Christianity a wooden cross is erected at The Sentry, Moretonhampstead.

27th **1634.** Bennett Petterfild pays the Buckland Monachorum parish receivers the 5s (25p) profit "brought in for the tinne workes of the pishe". Similar entries from other years during this period indicate that the tinworks owned by the church were situated in the Newleycombe Valley.

28th **1691.** Amongst John Windeat's stewards' accounts for the manor of Walkhampton is a payment of 1s (5p) to Ellis Geels for "cutting a Mazed Bullock on Egworthy".

2000. The first of a new series of boundary markers is emplaced on Tavistock's bounds. Situated on Whitchurch Down, near Middlemoor, a time capsule containing local memorabilia etc is buried at the spot before the large rough-hewn granite slab is lowered in place. Inscribed 'Tavistock Town Boundary/T AD2000 W/The Lions Club of Tavistock', the letters signify the parishes of Tavistock and Whitchurch.

29th **1881.** Commenting on the results of the recent census, and the depopulation of the area since the collapse of the mining industry, a newspaper reporter writing about the Tavistock district states that in recent years "There have been but few new houses erected, the foundries have been dull, many public-houses have closed, old buildings torn down, and no activity in any branch of industry. The locality has gained by genteel people taking on their abode here, which serves almost as a suburb for Plymouth, but we have lost in mining population".

1976. The Two Moors Way, the long-distance path linking Ivybridge and Lynmouth, is officially opened. Dated tablets stand at each end of the trans-Dartmoor section of the path, at Stowford Bridge and on the outskirts of Drewsteignton village.

30th **1453.** Peter Courtenay is instituted as rector of Moretonhampstead. He was later translated to Bishop of Exeter, and then Winchester.

1599. The Bishop of Exeter grants a licence for John Palmer to teach boys living in the parish of Buckland Monachorum.

31st **1793.** A new communion flaggon is bought for Ugborough Church at a cost of £10 15s (£10.75p).

1916. Lord Mildmay of Flete officially opens the newly-built Butterbrook Reservoir in Harford.

❋❋❋❋❋

June

1st **1551.** John Slannynge of London buys the Maristow Estate from Sir Arthur Champernon of Rollestone for £400.

1653. Extract from the diary of Thomas Larkham, sometime vicar of Tavistock: "This day twelve month I had the doors of the parish church shut up against me by Hawksworth a late trooper in the King's army chosen a little before to be churchwarden and confirmed by Glanville and others".

1698. Twenty-five tenants of the manor of Buckland-in-the-Moor, and three persons representing neighbouring Ashburton parish, beat the bounds of the commons of Buckland.

2000. A new boundary stone is erected near the footbridge over the River Taw at the head of Belstone Cleave. It is inscribed 'BB' (Belstone Bounds) and with the date '2000 AD' below.

2nd **1923.** James Dunning, lord of Throwleigh Manor, leads his tenants and other parishioners in a bound-beating of the commons of Throwleigh. At a meeting held previously "a sum not to exceed £1" had been earmarked for re-inscribing and re-erecting boundstones.

Throwleigh boundstone above Willtor Well (q.v. June 2nd).

3rd **1768.** The *Exeter Flying Post* carries a report of the "shocking murder" of Mary Smerdon and her two children at Widecombe on May 25th. All of the victims had their throats cut with a pair of scissors.

1843. In order to secure the future tenancy on Earlescombe Mill, miller John Lavers, son of Philip the present miller, takes a reversionary lease on the property on the lives of his two sons, Philip and John.

4th **1812.** In an advert in the *Exeter Flying Post*, the 153-acre estate of Higher and Lower Bowdley, Ashburton, tenanted by Richard Hellier, is offered for sale by auction. The auction will take place at the Golden Lion Inn, Ashburton, where Thomas Contins is the landlord.

5th **1779.** William Brown of Ugborough is paid his four guineas bounty money for enlisting in the Southern Regiment of the Devon Militia.

6th **1892.** Robert Burnard visits Wistman's Wood and takes some photographs of the dwarf oaks. An inscribed boulder there records that an oak tree was cut down near the spot in 1866. Interestingly, William Crossing later wrote that the stone was "about 50 paces above the central grove", but it now stands right on the edge of the copse, indicating how much the wood has extended upslope over the past century or so.

7th **1551.** John Farley of Lyneham lets his tenement and lands etc at Traylesworthy in Shaugh Prior to Wyllym Wolcomb of Plympton.

1783. Henry Rivers of the London Inn, Ivybridge, is paid £2 19s 8d (approx £2.98p) for supplying communion wine for Ugborough Church.

8th **1208.** In a plea heard at Winchester, Raunulph de Albamarle claims ownership of an "eighth part of a hide of land with a moiety of the advowson of the church...and a moiety of the mill" in the township of Taui St Mary (Mary Tavy).

1699. The overseers of Holbeton issue a settlement certificate to John Clarke so that he can be apprenticed to John Farley of Ugborough, "that he may attaine the Art and Trade of Weaving".

1743. Elizabeth Fogwell is a pauper in the Buckland Monachorum workhouse. On this day her sole worldly possessions are itemised. They are "one Bedtie 2 Blankets 1 Iron pot and a Cuberd".

9th **1817.** In his settlement examination William Glanvill of Plymstock says that he was born in Meavy, had lived in Bickleigh with his grandfather until he was 19-years old (when his grandfather died),

The frontage of Henry Rivers' London Inn, Ivybridge, which was converted to private flats in the 1980s (q.v. June 7th).

and at various times during his adult life had worked for John King of Sampford Spiney, John Willcocks of Buckland Monachorum and Edward Damarell of Shaugh Prior.

1870. An inventory of the goods and chattels belonging to the late James Endacott of Teignhead Farm includes an entry valuing fourteen bullocks at £90. These had inexplicably become fifteen bullocks when the stock was sold at Gidleigh Barton on 15th September following! Despite the questionable numeracy of the assessors, their valuation, in fact, proved to be fairly accurate, the fifteen being sold for £82 17s 6d (£82.87^1/$_2$p).

1993. HRH Prince Charles, Duke of Cornwall, officially opens the new High Moorland Visitor Centre in Princetown.

10th **1635.** In his will Robert Hamlin of Moretonhampstead bequeaths to his wife Sislye "the use and occupation of all my utensiles and howsholde stuffe as longe as shee shall dwell and keepe howse in and upon the Tennemente att Clifford wharein I now dwell".

1763. William Melluish, the son of Joseph and Susannah, is baptised at Huxham Church. He was later to become one of the first papermakers at Stowford Mill, which was founded by William Dunsterville in 1787.

1870. State pensions for the over-70s were introduced in 1908.

The ruins at Teignhead Farm, where James Endacott farmed in early Victorian times (q.v. June 9th).

Before that, most working-class people worked until they dropped (or ended up in the workhouse) – quite literally, as an inquest held this day at Tavistock poignantly indicates. This records that John Ash had died the previous week in an accident at Wheal Friendship (he was a surface worker). He is said to be "over seventy years of age". As suggested above, that he was still working at such an age was not in the least unusual for the period. Witnesses at the inquest also state that "he was a cripple and accustomed to walk with a crutch and stock".

11th **1868.** Sir James Brooke, 1st Rajah of Sarawak, dies at Burrator House and is buried in Sheepstor churchyard. Rather perversely, perhaps, in a land of granite, his tombstone is made out of red Peterhead granite!

12th **1741.** Elias Andrews of Buckland-in-the-Moor sells to James, Thomas and John Wills, six fields at Jurston in Chagford called Great Broadland, Berry, Lower Jurston Moor, Lower Hill, Lower Claypitt and "halfe of A Moory meadow adjoining to Lower Jurston Moor".

1997. Work begins on the reconstruction and conversion of the long-abandoned and semi-derelict buildings at Town Farm, Walkhampton. (The old farm buildings, and the two adjoining

cottages at the foot of Church Lane, now named 'Corner Cottage' and 'Town Cottage', have since been restored to habitable dwellings.)

Part of Walkhampton Town Farm during rebuilding work in late 1997 (q.v. June 12th).

13th **1795.** Richard Winter, high constable, orders the Ugborough constables "...to make diligent search...for all Idle disorderly Men, Rogues, and Vagabonds..." dwelling in Ugborough, and to bring them before the justices at the next quarter sessions. The reason for the round-up? All able-bodied vagabonds etc between the ages of 16 and 50 years were to be enrolled in the Navy!

1830. Houses in Buckland Monachorum, Milton Combe and Horrabridge are to be numbered for the first time. John Chappell is given the unenviable task of painting all the numbers, at 1d (less than ½p) per door.

14th **1861.** A curious report appears in the *Tavistock Gazette*, concerning the discovery, during demolition, of a dead fox in an upstairs room of an abandoned house in Ashburton. The report speculates that it is a fox which had been chased into the semi-derelict building some five years earlier by local huntsmen. The report further contends that, as the stairs of the property had by then already collapsed, "the only way the fox could have got into this room must have been by running up the wall". Perhaps it was a

species not hitherto reported on Dartmoor – a flying fox! Or, maybe, the press report had been held over from April 1st!

15th **1649.** Simon Hellier of Plympton St Mary becomes the owner of 1/8th part of Merrifield, which includes pasturing rights over Lee Moor, with common of turbary, estovers, housebote, haybote, plowbote and pasture in Torrecombe Wood. His son of the same name (his surname spelt Hellyer) later inherited, but obviously had little use for the commonable rights, for he was a clothier of Modbury. So, in 1692, the property and rights were sold to Frances Howell of Plympton for £260.

16th **1574.** An inquisition post mortem on Richard Pitton, who died on this day, records that he died siezed of a messuage, tenement and lands at Pitton, Widecombe, and also, rather intriguingly, a stamping mill called Pitton Mill, held of Thomas Southcott of his manor of Southall.

1781. The number of burials in Bickleigh suddenly doubles in this year, most of the deaths being recorded in June and July. The reason for such a dramatic increase? The majority of the burials are from amongst the personnel, and their families, of a vast army encampment stationed on the commons. On this day is buried another victim of the squalor of the disease-ridden camp, John MacEntyre, "a child from ye 50th Regiment of Militia".

17th **1669.** As part of the conditions of his taking a lease on Buckland Court, John Nosworthy is instructed to "find and provide for three persons sufficient meate drinke and lodgeing and stable roome grasse haye and provinder for their horses mares and gelding according to the time and season att such times as the said persons shall repair to the said Capitall Messuage for the keeping of the said [Manor] Courts or gathering the Rents of the Mannor or other occasions".

1870. A report in the *Tavistock Gazette:* "The remains of the late Sir Thomas Trayton Fuller Elliott Drake were on Wednesday deposited in the ancestral vault in the Drake Chapel at Buckland Monachorum church". The cortege had, in fact, begun its long journey at Nutwell Court, Sir Thomas Drake's residence, on the previous morning, the carriage proceeding slowly to Tavistock, where the body was laid overnight, before continuing to Buckland.

18th **1818.** John Burrows of Oreston in Plymstock gives a legacy of £100 to the poor of Buckland Monachorum, the interest upon which is to be distributed annually in bread.

19th **1885.** Notice is given in the *Tavistock Gazette* that the business of J.

& J. Sargent, millers at the Phoenix Mills, Horrabridge, "has been dissolved this day by mutual consent".

20th **1740.** William Creeper of Ugborough is given a settlement certificate by the overseers so that he will be able to live and work in Denbury.

21st **1832.** Tom and Sally Satterley, with the aid of friends and neighbours, build 'Jolly Lane Cot', the last dwelling on Dartmoor to be built in a day.

1994. A replica cross is erected on Ter Hill. The original, which had been removed to save it from further damage and decay, was later put on display in the High Moorland Visitor Centre and now stands in the adjacent Jack Wigmore garden.

22nd **1871.** The Wheal Lucky Mine sett is leased to J. Goldsworthy, captain of Wheal Creber, and James Crowell. Amongst the standard clauses of mining leases of the period, the lessees are also permitted to "erect all such Engines and machinery and build all such Counting Houses Sheds and other edifices (except burning or smelting houses) as may be necessary".

23rd **1826.** George Giles, Walkhampton manor steward, writes to John Gregory of Dunsbear, Tamerton Foliot, complaining that "your Man who lives in the House at Clacywell keeps four or five dogs with which he worries the other Commoners stock whenever they come any way near your Hedges and not unfrequently drives them off their accustomed Lear".

1859. A Walkhampton vestry accepts the tenders of William Fuge and James Chapple, masons, and Jown Cowling, carpenter, for restoration work to Walkhampton Church. Thomas May of Stonehouse is to be appointed superintendent of the works.

24th **1627.** The Woodlands Charity of Shaugh Prior is founded by John Hedde of Moreside, who gives the tenement called Woodlands to the parish, the rents upon which are "to be employed to the only use, profit, and behoof of the poor people of the said parish of Shaugh forever". Of course, as with all charitable bequests, the very precise word "forever", the meaning of which can hardly be misinterpreted, was often taken by later bureaucrats to really mean "until some official non-parochial outside body wishes to start meddling with it to change its terms"! In this case, however, bread was still being handed to deserving inhabitants of Shaugh Prior by the Woodlands Charity trustees at least as late as 1949.

1843. James Woodley grants the Halsanger Mine sett to James Maxwell and John Williams, under the more or less standard

terms and conditions for mining leases of the period. However, it appears that the prospective lessees may not have taken up the grant, for the lease, which is a draft only, was apparently not executed.

1938. The last known lease for working the Birch Tor & Vitifer Mine sett is issued to G. N. T. Taylor for £20 per annum rent and a thirtieth share of the profits from all tin sold.

25th **1860.** Colonel Wright of the Royal Engineers raises the subject of opening a rifle range at Butterdon with Charles Barrington, Duchy land agent, saying "there is a tract of moor near Hangershell Rock...which has been reported to me to be fit for the purpose". The range was duly built, and opened, but had then been abandoned within the year because the Duchy, not being the landowner, had had no authority to grant permission for it in the first place!

Target butt on the Butterdon Rifle Range (q.v. June 25th).

26th **1619.** Thomas Harris the elder, tanner of Ashburton, bequeaths his "four lyme pitts" to his eldest son, Barnard. The location of the pits is, unfortunately, not stated.

1866. Schoolchildren in the district have a day off to attend the official opening of the new railway line from Newton Abbot to Moretonhampstead. A granite block commemorating the opening, and inscribed with the names of all of the original directors, was

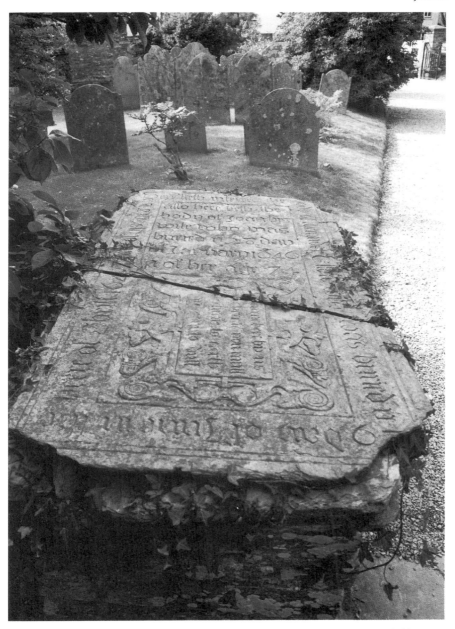

The oldest chest tomb in any West Devon graveyard (q.v. June 29th).

emplaced in Moretonhampstead Station on the same day in 1925.

27th **1722.** Dame Elizabeth Heywood grants a lease on Bridgepark alias Bridgetown in Walkhampton to James Barter, at a rent of 13s 4d (approx 67p) per annum.

28th **1708.** Arthur Fox, briefs collector for Devon, collects 7s 3d (approx 36p) for the previous eight briefs, or letters patent, which had been read in Meavy Church.

1723. Thomas Hele of Cornwood is charged with "tippling" until midnight at an inn kept by Elizabeth Woodward.

29th **1647.** Alexander Elford is buried at Buckland Monachorum. His final resting place is marked by one of the oldest chest tombs to be found in any Dartmoor or West Devon graveyard. Espying his great age in the inscription (as customary for the period, his age is not recorded in the contemporary burial register entry) really prompts onlookers to pause and reflect on the times which he lived through: when Alexander Elford was born, Elizabeth I had been on the throne for just seven years!

30th **1634.** Arthur Smerdon conveys part of Tunhill, Widecombe, to Richard Smerdon and Richard Hill in trust as part of the settlement for "a marriage by Gods permission intended to be solemnized betweene Richard Smerdon sonne of the saide Arthur And Anne Hill daughter of Roger Hill". The father of the bride was the Roger Hill killed in the Great Storm of Widecombe four years later.

2000. On the first day of their three-day Flower Festival & Village Exhibition, the villagers of Peter Tavy display the results of their 'Portrait of Peter Tavy' project, a project to create a photographic record of all properties in the parish, and their occupiers, at the dawn of the new millennium.

✹✹✹✹✹

July

1st **1788.** Richard Toop is paid half a crown (12½p) "for a Stone Sat up where a Thorne formerly Grew [called Copy Thorne]". This remains the only surviving boundstone standing on the Sheepstor/Walkhampton boundary.

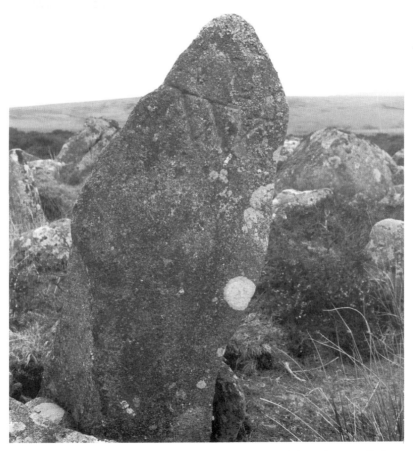

The boundstone near Combeshead Tor, set up in 1788 at the spot "where a Thorne formerly Grew" (q.v. July 1st).

1867. Tenders are invited for the "re-seating, making various alterations, and other works, in the parish church of Ugborough", to be submitted to the Reverend J. Sainsbury, Peek Mill Cottage, near Ivybridge, by 15th July.

2nd **1829.** The Whitchurch headstone to James F. Stanton records that he was "bit by a dog and died in consequence". Had he resided on the other side of Dartmoor he might have been saved, for both the Moretonhampstead and South Tawton contemporary registers have a small printed note pasted inside their front covers recording a recipe "For the Cure of the Bite of a Mad Dog"!

3rd **1834.** John Underhill pays £6 18s (£6.90p) for an oak tree, to be used for the shaft of a new waterwheel to be installed at Huckworthy Mill, Walkhampton.

4th **1633.** John Dunninge and Robert Toupe the elder inherit joint estates in Trehill, Ugborough, under the terms of the will of Hugh Fountayne Esq, late of Trehill and Newlands.

1683. As part of their marriage settlement newlyweds Henry Lambshead and Joan Mardon are granted "the room called the shopp with dwelling house adjoining" at Higher Brimley in Ilsington. The grantor is Richard Lambshead, father of the groom, and one of the trustees is Thomas Mardon the younger, brother of the bride. The other trustee is Haniball Corbyn.

5th **1677.** One of the legends concerning the Cabells relates that as Richard Cabell lay on his deathbed at Brook Manor, supposedly on this date, black dogs were heard howling outside the house.

1771. Richard Harris leases the rights to receive all "tolls duties profits privileges and perquisites issuing out of two weekly markets called Tuesday Market for weighing of yarn and wool and Saturday Market for selling of all commodities", plus the rights to the tolls of four annual fairs, all held in Ashburton. The lessor is George Walpole, Earl of Orford, 16th Baron Clinton, to whom Harris pays £1,525 for the 99-year lease.

6th **1805.** Amongst other bequests in her will, widow Mary Elliott of Ugborough leaves her estate at Turtley to her son, Thomas, and her house in Ugborough to her daughter, Elizabeth Beable.

1827. Sir Masseh Lopes writes to John Damerell of Burham informing him of a forthcoming drift of the Forest of Dartmoor and telling him that should the farmers attempt to drive the Walkhampton Commons then he, Damerell, shall "forbid them...[and]...order them to desist at their peril, as they can have no legal right to exceed their own boundary of the Forest".

7th **1987.** David Bellamy awards the children of Meavy School with a cheque for £500 for winning the regional prize in a national conservation competition.

8th **1893.** The vicar of Walkhampton records that he "read over the grave of an unbaptised child", the son of George and Emily Wakeham, aged just 14 hours. (Full burial rights could not be read over the graves of those who died unbaptised.)

2000. In an event which must surely rank amongst the most unusual in the annals of Dartmoor history, twenty or so intrepid souls, aided by volunteers from 42 Commando RM from Bickleigh Barracks, abseil down the tower of Chagford Church in order to raise funds for the tower restoration appeal: an event which also provided an opportunity for the author to take some photographs of Chagford town centre from a vantage point from which the town is not normally seen.

A view over part of Chagford from the top of the tower of St Michael's Church (q.v. July 8th).

9th **1840.** Homers and Lukesland bridges in Harford are destroyed by floods. They were both later rebuilt at a cost of £10 7s 0d (£10.35p).

10th **1561.** An inquisition post mortem taken at Exeter records that Richard Hamlyn died seised of a messuage and 80 acres of land in Chittelford, a messuage and 40 acres in Venton, a messuage and 20 acres in Dunstone (all in Widecombe), a messuage and 80 acres in

Dawton, Buckfastleigh, a messuage and 30 acres in Sherborne, Lydford, and 1/6th messuage and 40 acres in Doddysleigh.

1901. In his report on Wheal Friendship Arsenic Mine, J. S. James observes that "The absolute absence of the slightest attempt at method, convenience, or economic working in the laying out of the surface arrangements is amazing"!

11th 1799. Inhabitants of Ugborough, and other parishes in the Ermington hundred, who had been chosen by ballot to "provide Horses, Mares, and Geldings to serve in the Provisional Cavalry of the said County", are called to muster in Modbury, where they are required to present their animals, together with "proper Military Furniture for the same".

1837. Sir Ralph Lopes refuses to grant permission to George Frean to open a "gunpowder manufactory" on his land, expressing his unwillingness to allow the "introduction of any thing of the kind into the peaceful Vale of Bickleigh". Frean's quest for a site was finally successful when the Duchy granted land for the purpose at what is now the Powder Mills, near Higher Cherrybrook Bridge.

The highest of the giant wheelhouses at the Powder Mills, looking down into the Cherrybrook Valley to one of the two chimneys at the site (q.v. July 11th).

1853. John Northmore is convicted of having stolen birch twigs from Shaugh Great Wood. His 'haul' is valued at just 3d (less than 1$\frac{1}{2}$p)!

12th **1760.** A lease issued on this date reveals the origin of the strange (mis-spelt) names of "Hold Ischale", and similar variants, which appear in the contemporary and later Sheepstor churchwardens' accounts. They refer, in fact, to Holditch Hall, an alternative name for Hellingtown. The lease of this date refers to the variants – "All that messuage & tenement...called or commonly known by the names of Hallingtown also Holdichale".

1802. From the Widecombe registers: "NB. John Wrayford of Southstone [Soussons] applied to me this day to baptise a child after morning service the next day. It has since appeared that the child was carried to Manaton contrary to very ancient custom and there baptis'd".

13th **1624.** "Abel the base sonne of ffrancis Manninge was baptised the thirteenth daie July". So reads the first entry on the earliest surviving dated page of the bishops' transcripts from the parish of Buckland-in-the-Moor, one of only four pre-1706 pages of either the registers or the bishops' transcripts which now exist.

1836. In his will Roger Chubb of Peter Tavy leaves "All that my Freehold Dwelling House Garden Outhouse Field or Close of Land with the Appurtenances called South Ditch" to his trustees for them to settle various other bequests, reserving to himself "Thirty Yards of the said Field upon which it is my intention to build a Dwelling House". The new house, if built, is to be left to his two daughters after his death.

14th **1513.** Thomas Whyte, abbot of Buckland, issues a reversionary lease on "Walter Stondon's tenement at Dyttesham Rew next to the church", in Walkhampton, to John and Alice Pyke, with pasturing rights over the land "from Hokefordebrygge to Herrttorre and thence to Mystore".

15th **1632.** The annual drift of the northern quarter of the Forest takes place, and the animals are driven to Creber Pound. Amongst them is a black ox, later declared as forfeit by the Duchy reeve. This, in turn, prompted a lawsuit by its owner, Oliver Warren, claiming that the correct procedures respecting estrays had not been followed in the Lydford manor court. Whether he was able to reclaim his animal, and/or compensation, appears to be nowhere recorded.

1870. Walter G. Toop of Whitchurch, former pupil, and then pupil teacher, at the Tavistock National School, matriculates from London University.

2000. Ashburton's ancient Ale-Tasting and Bread-Weighing

Ceremony, nowadays held annually on the third Saturday in July, takes place. The principals at this year's event are Town Mayor Brian Miller, Bailiff Leo Locke, Portreeve Chris Monnington, Town Crier John Keeling, Ale Tasters Paul Knowles and Dave Crook, and Bread Weighers Dave and Doreen Lewis.

Ale-Tasting at the Royal Oak, Ashburton (q.v. July 15th).

16th **1595.** John Woolcott the younger of Hemiock leases Bowden in Buckland-in-the-Moor to Julian Burnell, wife of Thomas Burnell the elder of Buckland, clerk.

1835. Jonathan May, a farmer of Dunsford, is murdered on his way home after attending market day at Moretonhampstead. His headstone stands in Dunsford churchyard.

17th **1890.** In a report of a sudden flood at Beardown, a Mr Kerswill writes that "The picturesque clapper at Beardown succumbed, and all that now remains in position are two imposts...The remaining six...are all lying in the water a few yards below". The bridge was later repaired and can still be seen to this day.

18th **1617.** Richard Langworthy of Lyztwill (Liswell), gent, is buried at Widecombe. His tombstone, since destroyed, recorded that he had escaped the trials and tribulations of this world for a better one by observing "Now he lyveth in Heaven's joye, Never more to feel annoye"!

1690. The Mary Tavy churchwardens pay nine shillings (45p) to

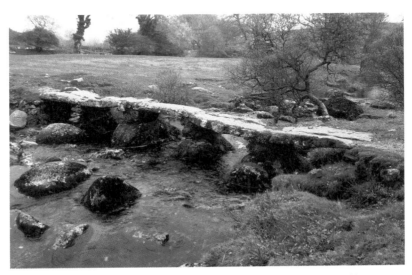

The restored clapper bridge at Beardown (q.v. July 17th).

one of the Lamerton constables for their share of "repairing of hearthfield beacon".

1840. George Templer issues a grant to Charles Barrett and others "to dig and search for Iron Copper Tin Manganese and other mineral products and Ores" on his land at Hey Tor.

19th **1777.** N. T. Carrington, author of *Dartmoor*, is born in Plymouth.

1902. Buckfastleigh inhabitants beat the bounds of their parish.

20th **1768.** William Langmead is paid 18s (90p) for taking Robert and Grace Ellieot, and Elizabeth their daughter, together with their scant possessions, from Ugborough to Belstone in compliance with a removal order issued under the settlement laws.

21st **1795.** In his diary, later serialised in the *Gentleman's Magazine*, John Laskey describes the moors above Cornwood as "the fag-end of Nature's work".

1992. The interior of Buckfastleigh's ancient 'church on the hill', the only church on Dartmoor which has a steeple, is totally destroyed in an arson attack. (For some years afterwards the blackened and roofless shell of the nave stood forlorn and empty, encased in a cage of scaffolding and wooden boards, a stark monument to the mindless vandalism of a so-called 'civilised' age. Its walls have since been consolidated and a new bell-chamber has been installed, and it is once again used for outside services and

Church Steps, at the foot of the long climb up to Buckfastleigh's ancient 'church on the hill' (q.v. July 21st).

other local functions, weather permitting.)

22nd **1512.** John Cole of Slade, and his merry band of followers, break into the pound at Brattor and make off with forty steers and ten geldings, livestock belonging to John Cole which had been impounded during the recent drift for not being entered on the Forest agistment roll. Sixteen steers belonging to others are also set loose during the incident.

1898. An entry in the Sheepstor School logbook records what many local families were forced to do during this period – "Samuel & Florence Greening left the parish as their house has to be pulled down for the convenience of the Reservoir Company".

1911. Messrs Peter & Son, writing on behalf of the owners of Moortown, Oakley, Langstone and Sortridge, all served by the Grimstone & Sortridge Leat, complain to Walter Peacock, Duchy steward, that the lessees of Merrivale Quarry not only pollute the leat with waste but also interrupt the water supply by diverting it for their own uses.

The giant crane at Merrivale Quarry now stands idle, and the deep quarry pit is filled to the brim with water (q.v. July 22nd).

23rd **1832.** George Giles, Maristow Estate steward, writes to William Hooper, stonemason, to complain that "The job you did at Longstone will be a lasting disgrace to you...The Dairy Roof is all but fallen in, and the Rain passes through the Roof of the Porch

Chamber just as if it was covered only with a sieve"!

1928. W. Arthur Clements begins work on cutting the inscription on the Ten Commandments Stones on Buckland Beacon.

24th **1240.** Twelve knights and their retainers, and a large throng of manorial lords and local peasants, gather "ad hogam de Cossdonne" to begin the perambulation of the Forest of Dartmoor.

1721. William Battishill, grocer of North Petherton, Somerset, leases two of his fields at Moretonhampstead to Alexander Whiteway Jnr, weaver, for a rent of 8s (40p) per annum.

25th **1853.** John Spry and William Worth, stonemasons, and William King, carpenter, are given the contract for building a new house at Lowery, Walkhampton. The new dwelling was abandoned less than half a century later, when the Burrator Reservoir was created.

26th **1831.** In his journal the Reverend Bray describes the cairn atop Water Hill as probably having been the true location of the King's Oven, an observation upon which William Crossing later poured scorn, but one which, in fact, turned out to be correct.

1887. From the Leusdon School logbook: "Examination this day. Annual treat. Broke up for holidays". From this it is not clear whether the "annual treat" refers to the examination or the holidays!

27th **1795.** William Stockman is granted a lease of "All that piece or parcel of ground formerly a Rabbit Warren" near Merrivale Bridge. He later enclosed aproximately 300 acres of ground at the site in order to create what is now known as the Merrivale Newtake.

28th **1569.** An agistment roll records that there are 1,583 cattle depastured in the western quarter of the Forest of Dartmoor.

2000. The Valiant Soldier, the "pub where time was never called", is formally opened as a visitor attraction by television personality Chris Denham.

29th **1676.** For the yearly rent of £1 Sir Nicholas Slaning lets to Edward Meade of Shittistor the messuage & tenement etc "called and known by the name of Dittisworthy also Dittsory Warren... together with comon of pasture on all the wasts...adjoining to the fforrest of Dartmoore for so many beasts & cattle as may be wintered on the premises...with liberty...to continow the said messuage...to A coinie warren as now".

30th **1858.** At the end of the trial of John Bickle, for the attempted murder of Joanna Bolt of Sampford Spiney, the judge decrees "It

The bar in the Valiant Soldier, the Buckfastleigh pub "where time was never called" (q.v. July 28th).

now becomes my duty to pass sentence of death upon you. That sentence will be recorded against you, but will not be carried out...but you must be prepared to pass the remainder of your life abroad in penal servitude".

1896. The Earl of Morley conveys a plot of land at Lee Moor to trustees John Bray and William Hore, china clay workers, James Bettes, joiner, and George F. Selleck, farmer, all of Lee Moor (plus other trustees of Plymouth), for the purpose of a new burial ground for the Lee Moor chapel.

1920. John Hannaford of Southcombe, Widecombe, receives his "Licence for One Motor Car". The annual licence fee is six guineas (£6.30p): his car is a new Model T Ford. It seems that this was sold 11 years later, for an auction poster issued by Rendell & Sawdye in 1931 advertises for sale at Southcombe "48 Bullocks, 269 Sheep and Lambs, Bay Cob, and Ford Motor Car".

31st **1914.** Prices of items listed on a bill issued by E. Beard, General Stores, Linchaford, Widecombe – $^{1}/_{2}$lb tea 10$^{1}/_{2}$d, 3lbs lump sugar 7d, 2lbs jam 11d and 3lbs nuts 1s 6d.

✳✳✳✳✳

August

1st 1873. Thousands of soldiers arrive at their base camp on Ringmoor Down for three weeks of training and manoeuvres.

2nd 1715. For a fine of £28, Dame Elizabeth Modyford grants a new reversionary lease on Notter, Sheepstor, to John Willcock, for one life in reversion of two. When the lease comes into force the rent is to be £1 per annum, plus a fat capon at Christmas, and the heriot £2 or the best beast.

1969. According to a statistical report 57,700 people visited Dartmoor on this particular day. Who counted them all?!

3rd 1842. George Giles, Maristow steward, writes to John Hannaford of Cadworthy in Meavy asking him to "prepare Posts to shew the Boundary across Wigford Down between Sir Ralph Lopes and Mr Scobell...the only working or dressing...would be to merely flatten a space about six inches square on the eastern side of the post[s]...and in that square to engrave deeply a bold L".

4th 1597. Sir Francis Drake of Buckland Monachorum grants his lands etc called Sampforde to Alice Reede, agreeing that after her death the premises "shall wholie remayne and come unto" Nicholas Reede, her son.

1826. The clapper bridge at Dartmeet is destroyed in a violent spate.

5th 1817. An auction held at the Seven Stars Inn, Exeter, offers for sale "All that the Fee Simple and Inheritance of the extensive Manor and Lordship of Gidley...Also the Messuage, Outhouses, Barton and Farm, Called Gidley Barton...Also the Rectory, Glebe Lands and Tithes of, and the Right of Patronage and Perpetual Presentation to, the Parish Church of Gidley".

1988. The first edition of the *Chagford Times* is published. As it is no longer available, I assume that the last edition was printed not long afterwards!

6th 1856. Henry Toop of the White Hart Inn, Horrabridge, receives a letter from the manor steward telling him that he must either "pull down and remove the Wheel and the Weir in the River Walkham adjoining your Wheelwrights Shop at Horrabridge", or enter into a new agreement for its use, "or it will be removed for you by other parties".

7th **1569.** William Strode, county sheriff, writes to Sir William Cecil to inform his that the muster rolls for Devon will be delivered slightly late. It is likely, however, that most of the rolls had been compiled by this date. Amongst those assessed on the South Tawton roll is John Ascotte, whose wealth in goods requires him to supply one almain rivet, two bows, two sheafs of arrows, two steel caps and one bill. Who will use his bows and arrows is not quite clear, for the parish apparently has no archers. The much larger parish of Tavistock, on the other hand, can provide 64 archers. Surprisingly, perhaps, even the relatively small population of Meavy can muster five bowmen.

8th **1842.** Thomas Andrew is caught by a Walkhampton inhabitant "Looking Over his flock of Sheep Apparently Counting them and leaving them on Walkhampton Commons". He is later fined at the Walkhampton manor court for illegally depasturing his flocks there.

9th **1670.** Mary Dyer surrenders her interest in Whimington in Sampford Spiney to John Drake of Ivybridge.

1893. Work on the Burrator Dam is officially commenced at a formal ceremony at the dam site, which had already been cleared and partly prepared for the building work that was to follow.

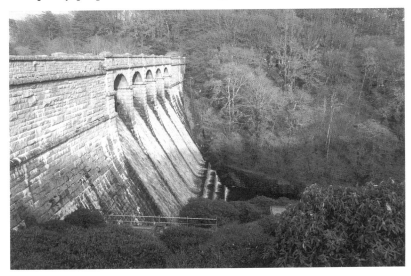

Burrator Dam, built in 1893 and raised by a further ten feet in 1928 (q.v. August 9th).

10th **1741.** George Coneybeare becomes the lessee at the manor mills in Buckland-in-the-Moor. His great-grandson of the same name, the fourth consecutive generation of eldest sons to be named George, later lived at Axtown in Buckland Monachorum.

11th **1903.** South Brent beats the moorland section of its parish bounds for the first time since 1871.

12th **1680.** John Drake of Ivybridge leases a house "neer Huckry bridge...in Sampfors Spiney" to Edward Adams, cooper, for a rent of 4s (20p) per annum.

13th **1877.** Baldwin J. P. Bastard, lord of the manor of Buckland-in-the-Moor, agrees to pay the positively extortionate sum of £1,050 in order to secure the purchase of two small fields near the Awsewell entrance to the estate, to save them from "possible appropriation to building purposes".

14th **1863.** John Kerslake, innkeeper of Tavistock, is fined £3 by the local magistrates for "permitting persons of notoriously bad character to assemble in his [ale] house". He is also told to reform his ways, or his licence will be revoked.

15th **1865.** The Buckland-in-the-Moor bailiff writes to the lord of the manor (living at Kitley, Yealmpton) to report that "The farmers have drove the colt drift today and brought in 14 colts off the common which do not belong there and others have escaped".

1912. The first service is held in the newly-built Peat Cott chapel. (This was to close in 1983.)

1941. RAF Harrowbeer is officially opened.

16th **1661.** In her will Johane Hamlyn of Lee in Shaugh Prior leaves five shillings, a sheep and "my redd Rugged cow" to her son, Christopher, "one standinge bedsteede" to her grandson of the same name and, after other minor bequests, the residue of her goods & chattels etc to her other son, John.

1816. The Tavistock Savings Bank is founded. Its hours of business are from 2.30 to 3.00 on Friday afternoons and from 6.00 to 7.00 on Saturday evenings. Interest is 4% per annum on deposits of more than 12s 6d (62½p). Four weeks' notice is required for withdrawals over £10, but smaller amounts can be withdrawn at only one or two weeks' notice.

1936. Work commences on the construction of the Fernworthy Reservoir dam.

17th **1996.** A pictorial map of Cornwood Parish, created by 16 artists and calligraphers, is unveiled by the Earl of Morley at the Cornwood Show. The map now hangs in the hallway of the village school.

Fernworthy Reservoir, as photographed during the drought of 1995 (q.v. August 16th).

1999. After many weeks of preparation, a few hours of sheer frustration, some choice words hurled at the computer (which had no affect whatsoever on its performance!), and a few six-packs (which worked wonders on the performance of both man and machine!), the Dartmoor Press website finally goes online.

18th **1783.** John Dunning, Lord Ashburton, dies. The epitaph on his memorial in Ashburton Church is said to have been written by Dr Johnson. The Reverend Charles Worthy, writing nearly a century later, was unimpressed, describing the monument as a "monstrosity".

19th **1807.** A Moretonhampstead diarist records that on this day "the French Officers [POWs billeted in the town] assembled on the Cross Tree with their band of music. They performed several airs with great taste".

20th **1814.** New excavations begin in another location on Dartmoor. Searching for tin? Copper? China Clay? Digging a new leat? Cutting peat? No! The diggers are American POWs planning to break out from the Dartmoor War Prison! Their plans are thwarted by Captain Shortland two weeks later, and the tunnels are infilled.

1842. James Jerwood, tithe commissioner, is appointed to

"...inquire, ascertain and set out the boundaries of the parish of Gidley...so far as the said boundaries abut upon Dartmoor and other commons, in the parishes of Lidford, Chagford and Throwleigh...", in order to resolve a dispute connected with the enclosing of Teignhead Great Newtake. It appears that the present boundary line in the vicinity of Stone Tor, which is, in fact, historically incorrect (as depicted on O.S. maps) might be that which was decided by Jerwood in arbitration of the dispute.

21st **1873.** The Prince of Wales reviews 10,000 troops on Roborough Down.

22nd **1832.** An urgent vestry is convened at Buckland Monachorum to "take into consideration the propriety of establishing a Board of Health in consequence of the Cholera raging in the neighbouring parishes of Whitchurch, Meavy and Sheepstor, as well as in the towns of Plymouth and Devonport".

23rd **1878.** The annual round of livestock sales are here again. Amongst the western Dartmoor farms advertising forthcoming auctions in today's *Tavistock Gazette* are Partown (139 sheep, 29 bullocks, 5 horses, 11 geese), Peek Hill (296 sheep, 46 bullocks, 4 horses), Hernspitt (111 sheep, 18 bullocks, 3 horses), Sortridge (235 sheep, 44 bullocks) and Cudlipptown (152 sheep, 21 bullocks, 5 horses).

24th **1947.** William L. Beer, aged 69, dies and is buried at South Brent. His headstone, paid for by members of the Rogers family of Wonton, records that he had been employed in the service of the family all of his adult life, since the age of 12.

25th **1557.** An inquisition is held at South Brent to enquire into the bounds of Brent Moor.

1991. A commemoration service is held at the RAF memorial on Hameldown to mark the 50th anniversary of the fatal crash of a bomber of 49th Squadron, and the worn incription on the stone is replaced with a new tablet.

26th **1889.** Robert Burnard visits Drewsteignton village and writes of it that "Flanking the village green are pretty thatch-roofed cottages with a good old-fashioned inn". These words could have been written yesterday, and his photo of the village square shows that little has changed during the past century.

2000. Ken J. Watson of Middle Meripit, with dogs Mini and Rik, wins the first two classes at the Whitchurch and Sampford Spiney sheepdog trials, held in one of Tom Cox's fields at Birchey Farm.

27th **1650.** A survey of the borough of Lydford records that the prison keep is in a very decayed and ruinous condition.

A row of cottages just off the square in Drewsteignton, a scene which has hardly changed in the century since Robert Burnard visited the village (q.v. August 26th).

Ken J. Watson of Middle Meripit, with sheepdog Rik, penning at the end of the second run at the Whitchurch and Sampford Spiney sheepdog trials (q.v. August 26th).

1981. The 'Tor Bus', which ran between Newton Abbot and Widecombe in the 1950s, is sold for £450 at a vehicle auction in Southampton.

28th **1858.** Amongst the vast array of equipment offered for sale at the closing of Hill Bridge Mine, Peter Tavy, is "an excellent Water Wheel with Iron Axle and Rim, 42 feet in diameter, 6 feet abreast, of first-rate construction and material".

29th **1789.** Thomas Reynolds is paid £1 for the post mortem certificate on William Heard, who had been killed by John Avent's mare in an accident at Horrapit, Buckland Monachorum. As a result of the accident, Avent is also ordered to forfeit the mare, as deodand, to the lord of the manor.

30th **1787.** Lawrence Lang charges just 8d (approx 3p) for thatching the Ugborough workhouse. The 55 nitches (bundles) of reed used for the work cost 6s 6d (32^{1}/$_{2}$p).

31st **1839.** In a letter to the *Mining Journal* a correspondent comments on the abolition (a year earlier) of the coining of tin in Devon and Cornwall, questioning "how a system, without utility or wisdom to recommend it, could have existed undisturbed for so many years". (This suggests that the commentator was not an historian, for the surviving records of the coinages in Devon – the quarterly rolls from Ashburton, Chagford, Plympton and Tavistock – are a valuable source of information for present-day researchers.)

✳✳✳✳✳

September

1st **1572.** Johan Whyte, born in "the howse of Knyght alias Edmondes in the forest of dartmore", is baptised at Widecombe.

2nd **1740.** A new lease on Dittisworthy or Ditserry Warren is issued to William Nicholls, a condition of the tenancy being that he will "build up the dwelling houses outhouses and hedges". Nicholls also covenants to provide one day's labour for the manor at harvest time, or pay a 4d (approx $1^{1}/_{2}$p) fine in lieu, a standard obligation of manorial tenants of the period.

1741. After reciting various minor bequests to relatives and servants, the will of Thomas Hele of Cornwood leaves almost his entire estate "unto my good friend Thomas Pearse the younger of Plymouth...son of Thomas Pearse of Court in the parish of Bigbury Gent".

1801. John Gest of Ugborough receives his income tax demand. His total tax liability for the previous year is just £2 5s (£2.25p)!

1893. The Reverend Sabine Baring-Gould, in the company of Mr Bussell, visits Sally Satterly of Jolly Lane Cot, Hexworthy, to record the words of some of her folk songs. As he later wrote, Sally could not just sit down and 'perform', but sang as she went about her daily chores, "so we went after her as she fed her pigs, or got sticks from the firewood rick, or filled a pail from the spring, pencil and notebook in hand".

3rd **1825.** The Wheal Friendship Company pays out a £100 bonus dividend to all its shareholders, bringing the total profit per share to £1,580 in the ten years since the last share call.

1928. William Crossing, Dartmoor's most renowned author, dies and is later buried at Mary Tavy.

4th **1834.** In one of his typically-phrased letters George Giles, manor steward, writes to Abraham Quick of Lifton to inform him that his application for a property has been refused – "To release you from a state of suspense and expectancy, I lose no time in apprizing you that you must look for some other place than Webbers for Residence". In a similar refusal, written at about the same time to a Richard Stranger of Bovey Tracey, Giles opened his letter with the words – "I fear we must remain Strangers to each other"!

5th **1794.** In a standard bastardy examination of the period Elizabeth Getsius of Ugborough swears before the justices that she is "...with child, and the said child is likely to be born a Bastard, and to be chargeable to the said parish of Ugborough...", alleging Robert Memry of Little Hempston to be the father. The child was baptised Robert Getsius on November 30th 1794. Interestingly, his headstone stands in the graveyard at Ugborough – he died on April 2nd 1858.

6th **1870.** "R Brendon's Sheep Dipping Cart" (as described in an advert) spends the day at, or near, the Castle Inn at Lydford. On the previous day it had been at the New Inn at Sourton. The charges for dipping sheep by this method are not stated in the advert.

7th **1556.** Phylyp Brockedon of Kyngsbrygge sells Chapell in Taynton Drewe (Drewsteignton) to Thomas Noseworthey of Maneton, tailor, for £15.

1812. There are many persons buried at Buckland Monachorum with naval or seafaring connections, more than in any other parish on Dartmoor or its borders. On this day is buried Thomas Tarraway, whom the register entry records was a master sail-maker.

8th **1756.** An unsigned bill for repairs to the church clock is given to the Ugborough churchwardens. Aside from a small charge for labour, the unknown artisan charges £1 11s 5d (approx £1.57p) for "2 new Rods & 2 Spills a Turner & 4 Plates & 4 Stes & a New Whell & Lences & 6 penerd of naills to Set ye plates 53 pound".

9th **1776.** The new pulpit at Ashburton is used for the first time, for a funeral sermon given by the Reverend Servington Savery.

1924. One of the top prizes in the sports events held on Widecombe Fair day is 15s (75p) for the winner of what the programme describes as a "Potato Race on Horseback"!

10th **1833.** William Courtenay, lord of the manor of Walreddon, and George Pridham, steward to John Harris, lord of the manor of Whitchurch, lead their tenants and other inhabitants on a beating of the bounds of the parish of Whitchurch.

11th **1994.** A large crowd gathers at Crockerntor to celebrate the 500th anniversary of a stannary court held on the site. On the occasion the present compiler rode on horseback from Holne, over a route which might have been taken by John Hanworthy of Cumston Farm, who attended the 1494 court as a jurate of Ashburton stannary.

12th **1708.** The parishioners of South Tawton donate 10s 6d (52^1/2p) towards the brief, or letter patent, read in their church to raise money for "building a Protestant church in ye district of Oberbarmen in ye Dutchy of Berg within the Empire of Germany under his Highness of ye Electer Palatine of ye Rhine".

1760. A maintenance order is issued instructing the overseers of Ugborough to pay a shilling a week to the wife of Nicholas Brown "...for and towards her support until the said Nicholas Brown shall again return..." from serving with the Fourth Battallion of the Devonshire Militia.

1782. In his will Amos Crymes, vicar of Buckland Monachorum, leaves his wife, Mary, "all that my perpetual advowson donation and right of presentation of in and to the Vicarage of the parish and parish church of Bucklandmonachorum aforesaid and all that my rectory impropriate and Great Tythes of and belonging to the said parish".

13th **1792.** Mary Tippett and Sarah Eden of Ugborough are delivered to the county bridewell in Exeter by William Prowse, constable. Remarkably, the signed receipt for their delivery, issued by jailer William Ford, has survived in the Ugborough archives.

14th **1821.** In his settlement examination Isaac Bowden of Ashburton, labourer, states that he formerly worked for James Woodley of Halsanger (with whom he also served his apprenticeship), Mr Wills of Smallacombe and Mr Smerdon of Welstor, and had also worked in Newfoundland for a year.

1937. South Brent's Roman Catholic Church is dedicated to St Dunstan at an official opening ceremony conducted by the Bishop of Plymouth.

1940. An entry in the Walkhampton vestry minutes records that a collection amongst the parishioners had raised £50 in aid of the Tavistock & District Spitfire Fund.

15th **1991.** The Dartmoor Tinworking Research Group holds its first public open day at the excavation site of the Upper Merrivale blowing mill.

16th **1874.** At a Sampford Spiney vestry, it is resolved that "the requirements for School accommodation in this Parish can be met by an arrangement with W Parlby for the use of the School house at Huckworthy Mill".

1990. A new boundary stone, bearing the initials of Ian Mercer, former steward of Holne Manor, is unveiled during Holne's beating of the bounds.

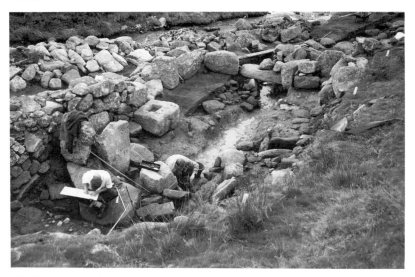

DTRG excavations in progress at the Upper Merrivale blowing mill – during the 1992 season (q.v. September 15th).

17th **1639.** An accident at Ilsington brings the little schoolroom above the lych-gate crashing to the ground. Miraculously, all of the children in attendance escape unhurt and, as a contemporary writer records, "not any number of them [was] any wayes enfeebled from Doeing its propper office as in former times"!

1686. Mrs Elizabeth Cabell of Buckfastleigh is buried in linen contrary to the laws of the day, in consequence of which her executors have to pay a penalty of £5 for failing to abide by the Act for burial in woollen.

1737. Having been paid poor relief by the Brentor overseers during a sickness lasting many months, Elizabeth Smith is given final release from her suffering by a higher authority, as this entry in the overseers' accounts reveals: "September the 17 to John Smith towards the funerall of his wife 3s [15p]".

1824. *The Plymouth Herald & Devonshire Freeholder* reports on the recent attack, by footpads, on a Mr Brown, tanner of Buckland Monachorum. Whilst on his way home from Plymouth, he was attacked near Hartley Gate by the pair, who demanded his money and threatened to kill him if he made a noise. Hearing the sound of approaching horses, Mr Brown shouted "Murder!", and the villains ran off.

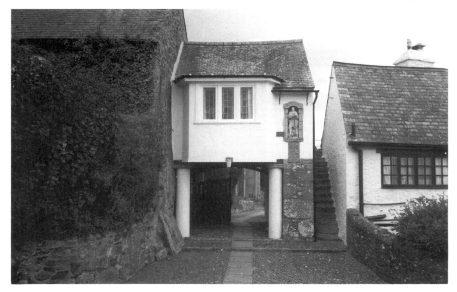

The 'new' schoolroom above the lych-gate at St Michael's Church, Ilsington (q.v. September 17th).

Looking westwards across part of Ashburton from the top of the tower of the Chapel of St Lawrence (q.v. September 17th).

2000. The tower of the Chapel of St Lawrence, Ashburton, normally closed to visitors, is opened as part of the Heritage Open Days Weekend. It is the *only* building in the entire Dartmoor National Park whose owners or trustees could be bothered to open their otherwise locked doors for a few hours as part of this unique nationwide millennium year event.

18th **1865.** Richard Smerdon, executor of the late Alice Smerdon, gives the trustees of the Reddicleave Estate notice of his intention to quit Reddicleave Farm, Buckland-in-the-Moor, at Lady Day next (March 25th 1866).

19th **1870.** A serious accident occurs at the Sticklepath "Works of Mr Finch, edge-tool manufacturer" (as described in a later press report of the incident). A worker named Calloway is "fearfully bruised and cut", but is rescued from certain death by a neighbour who, upon hearing the loud report of a grindstone bursting, rushes in and stops the waterwheel, "or the poor fellow [Calloway] would have been torn to pieces".

1892. A tablet in the wall of St John's Church, Horrabridge, records that "This stone was laid on September 19th AD 1892 By The Right Hon. Sir Massey Lopes, Bart.". The vicar of the new church, dedicated to St John the Baptist, is the Reverend Edward J. Windsor; the churchwardens are Richard Willis and Richard A. Toop.

20th **1680.** William Lord Petre grants a mining sett on Brent Moor to Thomas Foster of South Brent.

1801. George Leach sells Elford Town Farm to William Moore for £2,800.

21st **1855.** William Saunders takes a 60-year lease on Brent Moor to search for, and work, "all manner of quarries, beds, pits, seams and veins of china clay, china stone, decomposed granite and felspar and other clay earth or material of a like nature capable of being used in the manufacture of earthenware or porcelain".

1876. The only documentary reference to Devil's Bridge Mine which the present compiler has found occurs in the Walkhampton vestry minutes of this date, when it is resolved to "summons the Manager of the Devils Bridge Mine for the sum of £2 5s 10d [approx £2.29p] the amount due for rates from the Company".

1997. According to a government report published this day, there are 32,138 persons living within the boundaries of the Dartmoor National Park. This human population is, of course, heavily outnumbered by the livestock which, according to a 1993

Aside from some field boundary walls, the only surviving structure near the site of the short-lived Devil's Bridge Mine is this small ruinous building, probably an outbuilding associated with the smallholding established there in the late 19th century (q.v. September 21st).

agricultural census, include 221,559 sheep, 58,809 cattle, 6,157 pigs, 18,132 fowls, and 560 goats – but, apparently, no ponies! The smallest parish, by the way, in terms of population size, is Sheepstor, which has just 49 inhabitants.

22nd **1602.** In a dual ceremony at Buckland Monachorum Church, Francis Drake marries Jane Bampfielde, and John Bampfielde marries Elizabeth Drake.

1848. The headstone to 15-year old Harriett Endacott of Belstone records that "her mortal life was terminated by means of a thunder storm".

1972. Meldon Reservoir is formally opened by Peter Mills, MP.

23rd **1816.** At a Harford vestry, the parishioners agree that "all Carts... employed...on the highways, that is to say a Cart two horses driver and a Man to Dig and Load, shall be allowed seven shillings a day and no more, and for a Man and two pack horses three and sixpence a day...and that all Labour on the highways shall be performed from eight o'clock in the morning to five in the evening allowing one hour at noon".

1831. Elizabeth Phillips of Ugborough is granted 3s 6d (17$\frac{1}{2}$p) weekly, to be paid by the overseers of Ugborough, to maintain

Meldon Reservoir, opened in 1972 (q.v. September 22nd).

herself whilst she is an out-patient of the Devon & Exeter Hospital.

24th **1870.** Dartmoor-based skygazers of yesteryear fared far better than solar eclipse-watchers of August 1999, or lunar eclipse-watchers of January 2000, as a report in the *Tavistock Gazette* indicates – "An unusually brilliant aurora borealis was observed from this neighbourhood...which at times shed almost as much light as a full moon".

25th **1683.** A Buckland-in-the-Moor manor boundary report describes Seven Lords' Lands as "Hoartsberry where the seven Lords meete, and sevven stones are pitched so up together to each Lord a Stone...", proving, absolutely, that the spot was a place where the lords of the seven manors of the Haytor hundred held open-air meetings, rather than the spot where the boundaries of seven local manors met.

26th **1870.** Amongst the items offered for auction at Gnatham, Walkhampton, are a corn wagon, a double-action turnip cutter, a reed comber, a turnip scuffle, a tormentor, a granite roller, a chain harrow, a patent weighing machine, a double plough and a turnip drill, most of these implements being "nearly new and combining the most recent improvements".

27th **1790.** The first day of a month's training at Plymouth for the Southern Regiment of Devon Militia, as per a notice issued by the

constables to militiamen of Ugborough, Harford, South Brent and other parishes in the Ermington hundred.

1823. The Plymouth & Dartmoor Railway – a tramway for horse-drawn wagons – is officially opened.

28th **1827.** A letter directed to James Holman Mason, Duchy steward, reporting on an illegal drift of the Walkhampton Commons instigated at the behest of Sir Massey M. Lopes, states that "the number of Beasts so impounded...[from]...the Forest amounted to nearly two Hundred, and there were many others belonging to persons who held lands in venville". (Large numbers of cattle had been forced to seek shelter on the commons in order to escape a vicious thunderstorm which had broken over the Forest of Dartmoor, whereupon Sir Massey initiated an immediate drift of his commons! He demanded 1s (5p) per head to release them from his pound, but was later forced to withdraw these demands.)

1841. A meeting is held at the Bedford Arms, Tavistock, to assess the rent charges in lieu of tithes for properties in Brentor.

29th **1306.** Richard Rauf, Hamlin de Shirwell, William Togot, Richard Stevene and James de Woghby are the Duchy's tenants at Donebrugge. It has been suggested that this reference, in the bailiff's accounts, points to the formation of the settlement at what is now called Dunnabridge, there being no mention of the placename in any earlier documents.

1580. Jherome Mayhew of Boringdon lets the messuages and tenements of Weymyngton and Down Hous in Sampford Spynye, with common of pasture on Bytlym Downe, to William Baker for an annual rent of £3 6s 8d (approx £3.33p).

1667. Richard Smerdon sells Tunhill in Widecombe to Nicholas Leaman.

1699. John Pollexfen Esq of Great Wembury lets the "moietie or halfendaele of one Tenemt called Hentorr...wch said Tenemt doth Containe by estimacon ffiftie acres" to Philip Searle of Portworthy in Shaugh Prior upon condition that the latter "shall or will within the space of three years...Erect and build...one good and sufficient Dwelling house in & uppon some part of the said Tenemt...and...a sufficient ffence & ward of Stone wall or hedge in & about the said Tenemt for its defence against the said Comons called Lee moore".

1770. On the same day 71 years later Richard Nichols, a hatter of Plymouth Dock, becomes the tenant at part of Willings Walls.

1899. Woollcombe & Sons produce their report on a proposal by the Paignton Urban District Council to build a dam and reservoir

on Ruddycleave Water. The proposal did not come to fruition, and the PUDC later chose the Venford Brook for the site of its new reservoir.

30th **1723.** Thomas Hele of Fardle leases Charles Tenement in Cornwood to William Heard, "Together with Comons of Pasture & Turbary upon the wast or Comon ground of Heddon". The rent is £1 12s (£1.60p) per annum, plus two fat capons or 2s 6d (12^{1}/$_{2}$p) at Christmas.

1792. Joseph Sawdye is appointed clerk of the parish of North Bovey.

1909. Captain U. Colborne is appointed sexton of Ugborough, replacing John Smerdon who had been dismissed from his post for various misdemeanours.

✳✳✳✳✳

October

1st **1731.** John Williams of Ugborough dies after a short illness. The overseers give him a typical pauper's funeral of the period, costing 1s (5p) for making the grave, 1s for the affidavit for burial in woollen and 3s 6d (17^1/₂p) for the wollen shroud, candles, and other expenses; 2s 6d (12^1/₂p) is also paid to Margery Brooking for "laying him forth" (ie. preparing the body for burial). The overseers have little sympathy for Mary Williams, his widow – six weeks later she is evicted from Ugborough under the settlement laws.

 1956. A new village hall, renovated at a cost of just over £4,000, is opened at Meavy. On the occasion 65-year old Ethel Bowden recites a poem which begins "In Devonshire near Dartymoor there is a place called Meavy, And if you say there's better ones well no one would believe 'ee". (These words are in stark contrast to those of Henry Woollcombe who had visited the spot 135 years earlier almost to the day (October 14th 1821), for on that occasion he had written in his diary "Meavy is a very retired spot without any society and the people a rude race"!)

2nd **1713.** The Hele Charity accounts record the receipt of £6 from Walter Narramore of Sheepstor "for the fine of a Reversionary Lease to him granted in the third pt of Eastendon etc for one Life after two".

3rd **1555.** The inquisition post mortem of Thomas Wolcote records that he died siezed of 1 messuage and 110 acres of land in Fen and Kenworthye, 1 tenement and 44 acres of land in Shaplegh Hyllyng, and rents from tenements at Barchworthy, Hurtsow and Wille-hedd, all in Chagford.

 1859. Coplestone L. Radcliffe, Maristow steward, offers to let Combeshead in Walkhampton to John Harvey for £21 per annum.

4th **1186.** John the Chantor is instituted Bishop of Exeter. Shortly afterwards he appropriates the church at Ashburton to the Dean & Chapter of Exeter.

5th **1837.** John Pearse, shoemaker, absconds from his house in Buckland Monachorum village with all his belongings, leaving large arrears of unsettled rents. He does not get very far, for he is found the very next day living in a house in Seven Star Lane,

Tamerton Foliot, whereupon all his goods are distrained in order to settle the debts.

6th **1564.** Thomas Watts of Tavystoke sells Combshed in Harford and Pethill in Cornwood to Andrew Bonnsall of Shyttistor (Sheepstor) for "the sume of twentie marks of lawfull monye of England".

1902. A letter sent by the Board of Education to the Whitchurch School Committee demands to know why plans have not been formulated for building a new school at Merrivale.

7th **1848.** Rather curiously, perhaps, it appears that the churchyard at Whitchurch was not previously properly fenced or walled, for on this day the Reverend R. Sleeman, at the behest of the parishioners, agrees to finance the costs of enclosing the burial ground in order to "protect it from the nuisances and immoral conduct being carried on".

8th **1674.** An inventory of the goods of Richard Hamlyn of Widecombe records that he owned these livestock when he died – 4 oxene, 3 melche kine (milking cows), 5 young bollockes, 70 sheepe, 1 laberd mare and 4 swine hogs.

1790. Amongst the jurors sworn in at the Holne manor court are Thomas Hamlyn, Luke Pearse, Richard Stranger and John Worth.

9th **1832.** 5/6ths of Knowle Daveytown in Walkhampton is bought by Sir Ralph Lopes for £225 from George P. Adams and George Leach, trustees of the will of Jonathan Elford.

10th **1239.** King Henry III bestows upon his brother Richard, Earl of Cornwall, the manor and castle of Lydford, and the Forest of Dartmoor, in return for an annual fine of £10.

1833. John Head, Buckland-in-the-Moor manor bailiff, records, in his inimitable style – and with blatant disregard for the orthography of even simple words! – a payment of 7s 6d (37^1/2p) to William Winsor for sawing timber and making a wheelbarrow for hoisting work at Awsewell Mine – "Ped Wm Winsor and man the soing and maken a Welbora and fixen in Work for hoisten: 7s 6d".

11th **1832.** Thomas Greep, landlord at the Church House Inn, Walkhampton, is paid £4 17s 6d (£4.87^1/2p) for supplying "Dinners & Grog for the Tenants" after the manor court.

1836. A. J. Nicholls, timber merchants of Coxside, are requested to supply timber boards of "good sound American Birch full two inches thick, the Boards to be 10 feet in length and the extreme breadth of the floor is 21 feet, including two Drift Boards", for a new threshing floor in a barn at Gratton Farm, Meavy.

12th **1761.** The receivers of Ugborough settle the bills for large

The church house at Walkhampton, formerly an inn, where Thomas Greep was the landlord in the 1830s (q.v. October 11th).

quantities of ale supplied for a festive occasion – not identified, but possibly the village fair? Agnes Feasant had supplied 36 gallons of ale (approx 162 litres), whilst Elizabeth Combe had supplied 27 gallons (approx 121 litres). And the bills for these vast quantities? – just £1 16s 0d and £1 7s 0d respectively (total £3.15p)!

Ugborough Village Fair, 2000 (q.v. October 12th).

1956. The obituary report on Jack Warne of Postbridge, published in the *Tavistock Gazette*, includes extracts from his own personal reminiscences about working at Hexworthy Mine.

13th **1806.** William Giles pays the Maristow Estate for dues on tin raised from Ailsborough (£1 14s 1$^{1}/_{2}$d) and Narrator Pits (7s 7$^{1}/_{2}$d) – approx £1.71p and 38p respectively.

14th **1574.** Nicholas Turner, bailiff to William Strode, confiscates "ii styers iii yers of age of Ric. pyers at backmore" in lieu of ten shillings (50p) rent arrears which had been owed to Strode for five years.

1754. A "View and perambulation of the Commons of ye Borough & part of ye parish of Lydford" is undertaken.

15th **1707.** Sir Edward Southcott of Witham in Esssex and John Caryll Esq of West Grimstead in Sussex "trustees for the benefit of the Rt Honble Robert Lord Peter [Petre] during his Minority" lease a reversionary interest in Brent Mills to John Codd of South Brent.

16th **1769.** William Windeat, a pauper in the Ugborough workhouse,

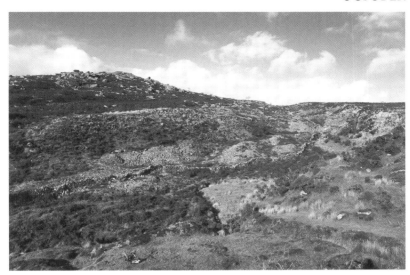

Tin works along the Narrator Brook (q.v. October 13th).

spent nearly 25 years working on the roads in the parish (he was admitted to the workhouse in 1753). Work was 10-12 hours a day, six days a week, 52 weeks a year – aside from Sundays, Christmas Day was the only day off. The weekly workhouse road labour sheets for the period even record exactly where he, and the other pauper labourers, worked. On this date they begin a six-day stint resurfacing the road(s) at what the worksheet describes as being located "between Venncross & Langfordown & nigh Bowcross".

1772. Three years later to the day William Windeat and the other workhouse inmates have worked their way round the parish roads to roughly the same place, and are in the middle of a stint repairing the road "between Venncross & Sign of the Owl".

17th **1884.** "The little church at Princetown presented a pleasing appearance on Sunday last, on the occasion of the harvest festival...As the church is far too small for the needs of Princetown, and the place is rapidly growing, an effort is being made to add a chancel to the present building". So reads a report in the *Tavistock Gazette*. In stark contrast to these words, today the redundant church at Princetown presents a depressing appearance, is too large for the present needs of the community, will cost in excess of £250,000 to repair and is a building which nobody wants.

18th **1799.** At a magistrates court held at Sackersbridge, Richard Winter

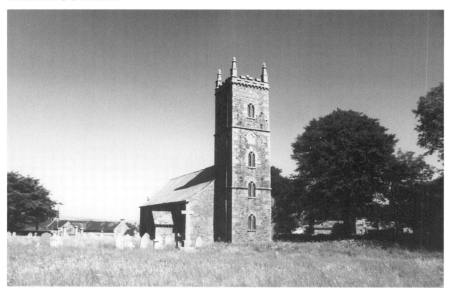

Will it be saved? – the now redundant Church of St Michael's & All Angels, Princetown (q.v. October 17th).

This is the site upon which St Luke's will rise, phoenix-like from the ashes, as seen in mid-July 2000 at the start of construction work (q.v. October 18th).

and Philip Manning are appointed highway surveyors of Ugborough for the following year.

2001. Yes, that's right – Not only does this book provide data on events of the past, but also foretells of events which will take place in the future! It is hoped that Buckfastleigh's new church of St Luke's, presently under construction, will be completed in time to be consecrated on St Luke's Day 2001.

19th **1860.** In an article on the recent election of the borough porteeve and other officials, a Tavistock newspaper reporter writes that "The office of pig-drover points to an earlier stage of civilisation, when public pigs were bores, and when these obstinate but edible quadrupeds were even more than at present, the enemies of progress"! At the court day, J. Algar and J. Warren had been elected pig-drovers for the year ensuing. By this date the offices were, of course, sinecures.

20th **1784.** In a rather bizarre case of petty theft, William Prowse, Ugborough constable, is ordered to search the house and outhouses of John Searle of Cheston for "...a white loom petticoat...the property of Ann Searle...feloniously...carried away out of a ffield of the Revd James Lyde". Whether the petticoat was discovered is not recorded.

21st **1638.** "...the extraordinarie lightening came into the church so flaming, that the whole church was presently filled with fire and smoke, the smell whereof was very loathsome, much like unto the sent of brimstone, some said at first they saw a great fiery ball come in through the window and passe through the church...". So reads an extract from the opening passage of a contemporary account of the event which has since become known as the Great Storm of Widecombe.

22nd **1702.** Thomas Hele the elder of Fardle grants to Nicholas Browne, and others, Fardle Manor, Fardle Mills and tenements at and near Lutton and Pennaton called Higgints, Browne's, Hanger's, Lapthorne's, Weare's Cottage, Burrough Leys, Benets Park, Calstone Beeres Cottage and Great Row, Stagrove alias Staggen, Collins', Edgecumbe's, Jellings, Unicks, Stibb Park and Clifferton.

1748. The Bovey Tracey manor court rolls record that upon the death of the Reverend George Hunt, brothers-in-law Robert Clapp and Thomas Luxton are admitted as tenants at Parke.

23rd **1837.** John Pearse, a shoemaker who had absconded with his belongings to a house in Seven Star Lane, Tamerton, leaving rent arrears on a cottage in Buckland Monachorum, forfeits £1, this

A SECOND
AND MOST EXACT
RELATION
OF THOSE SAD
AND LAMENTABLE

Accidents, which happened in
and about the Parish Church of
Wydecombe neere the *Dartmoores,*
in *Devonshire*, on Sunday
the 21. of *October* last,
1638.

PSAL. 46. 8.
Come, behold the workes of the Lord, what desolations
hee hath made in the earth.

LONDON,
Printed by *G.M.* for *R: Harford*, and are to be sold at his
shop in *Queenes*-head-alley in *Pater-noster-row* at the
guilt Bible, 1638.

The front cover of the contemporary pamphlet on the Great Storm of
Widecombe, which was printed in London just three weeks after the
event (q.v. October 21st).

sum being "the net proceeds arising from the sale of distress of his goods fraudulently removed".

24th **1617.** Gabriell Aptor is buried in Ilsington. He was, according to an entry in the Widecombe register, "spoyled in a tin worke".

25th **1762.** Thomas Stentaford presents a rather breathless bill – no punctuation! – to the Ugborough overseers. His charge for repairs to the workhouse comprising "taking down and rebuilding the Steps & the Steps at the garden geate an the gearden wall & puting in of iron work to henge the geat & taking up the Chimney heath & makeing a gotar under the same & out through the house & new making the heath & taking out the fornice & walling it in again" is just over £2.

26th **1691.** The will of William Savery of Slade leaves to his cousin, Prudence Hele, widow, "my new gold watch and Dyamond Ring and my two other Rings with Rubies and Emeralds".

1935. The new extension to Buckfastleigh churchyard, given by Joseph and Elizabeth Hamlyn, is consecrated.

27th **1640.** Sir Francis Drake leases to Obadiah Wickett of Sampford Spiney, carpenter, "All that dwelling house [wch he hath lately erected and built] and a quarter of an acre of land lyinge adioyninge & uppon the North side of the said house uppon a Certaine downe called Bitlyme downe and adioyinge to huckworthy bridge".

28th **1652.** "Roger Weeke gent was Buried the 28th of Octob und[er] ye church". So reads an entry in the North Bovey burial registers. Roger Weeke's time-worn ledger can still be seen in the floor of the nave today which, with the burial entry, proves the place of burial absolutely, which is mistakenly given as South Tawton in the Weeke pedigree in the *Visitations of Devon*.

1839. Isaac Stancombe of Oldsbrim, Widecombe, is refused a lease on Vinneylake, Walkhampton, the grounds being "the loss of your wife, and the ages of your two daughters and son, when taken in connection with your own advanced period of life; and well knowing how much depends on the domestic management of the Farm House, which is best governed by the authority of a wife". This refusal was, in fact, later rescinded, and Stancombe was granted a lease on the Walkhampton tenement.

29th **1921.** A brief report in *The Illustrated Western Weekly News* states that "It is rumoured that work at Belstone where Dartmoor granite has been dressed for export to France to be used for memorial crosses will be discontinued. The colour of the granite is said not

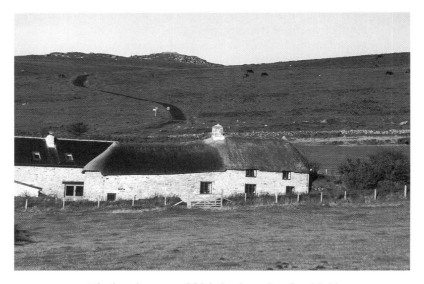

The longhouse at Oldsbrim (q.v. October 28th).

to give satisfaction".

30th **1951.** Dartmoor officially becomes a National Park.

31st **1889.** Henry R. Toop is requested by the Sampford Spiney vestrymen to attend a committee meeting at Exeter "to protest against the proposed basis of rating [for the purposes of county rates] for the parish of Sampford Spiney".

1898. The first Mid Devon Hunt meet of the new season is held at Fernworthy. A newspaper report records that a fox was picked up at Assycombe, chased all the way to Birch Tor and Grimspound, then all the way back to Gidleigh Park, where the fox went to ground.

✳✳✳✳✳

November

1st **1716.** Included amongst the clauses of a lease of Fardle Mills are pasturing rights for "one horse or nag or Mare and comons for Geese and six Swine Hogs in ffardle moor", and also "liberty to have and take dry and broken small wood which shall fall from the trees in ffardle moor and also comon of furse and heath in Hanger Downe and comons of pasture there for one horse nag or mare three bullocks and twenty Sheep".

1769. An unknown person is buried at Widecombe, "that was found dead out in ye moor".

1815. A note in the Princetown register: "Dartmoor Chapel and Burying Ground Faculty granted for the interment of the Dead Nov 1st 1815".

1907. The Reverend H. Hugh Breton is instituted as vicar of Sheepstor.

1982. The newly-formed Kelly Mine Preservation Society holds its first meeting.

The restored interior of the dressing shed at Kelly Mine, showing the quadruple Californian stamps driven by a Blackstone oil engine (q.v. November 1st).

2nd **1571.** Wyllam Ascott and Bartholomewe Northmore, wardens of South Tawton, present their accounts to John Wiks and Wyllyam Battishill. The sum of 7s 8d (approx 38p) is handed over to Thomas Venycomb "being Hed warden of the sd pishe [parish]".

1810. The obituary columns in the *New Brunswick Royal Gazette* record that on this day "John Venning...Englishman...lost his foothold whilst at work on the steeple of Saint John's church" and was killed instantly. John Venning is buried in the Loyalist Burial Ground, St. John, New Brunswick, Canada. He was the son of Robert and Martha Venning of Buckland Monachorum.

1936. Mary Moses of Nattor writes to the Maristow Estate steward to report that "In the gale of Saturday morning our higher Shippen roof partly blew off", and requesting that immediate attention be given to repairing it "before the winter weather sets in and the Bullocks come to the house".

3rd **1813.** A brief, or letter patent, is issued to raise funds for the rebuilding of the tower of Walkhampton Church, stating that it has "become so ruinous that the parishioners cannot assemble for Divine Worship without great Danger of their Lives".

1824. Ilsington parishioners who receive a share of Mrs Hale's bounty (charity) on the first Sunday in November this year are Sarah Hore, aged 79, Rebecca Hore, aged 77, Mary Padden, aged 70, Richard Payne, aged 71, William Marley, aged 70, and Agnes Prowse, aged 68. They receive just under £1 18s (£1.90p) each.

4th **1719.** John Williams leases to Lewis Jutsham one of the Piles Newtakes in Harford, described as "All that one large close of land & pasture with thapputenance called or comonly known by the name of Higher Old Pyles sometimes parcell of One Tenement Barton or ffarm comonly Called by the name of Old Pyles".

1797. Amongst the vast quantities of liquor drunk at an election party held by Walter Palk of Ashburton is the staggering total of 612 bottles of red port, the cost of which is just £107; the total cost of the function comes to just over £219. The party, by the way, was held for electors *before* the election – not surprisingly, Walter Palk won!

5th **1804.** The churchwardens and overseers of Ugborough are fined £20 by the Lieutenant of Devon for "not producing a fit Person to serve in the Permanent Additional Force in the Room of David Oldney [Substitute for James Mitchell] who died on the 8th Day of December 1803".

6th **1782.** John Shaplain is found drowned in the Plymouth Leat on Roborough Down.

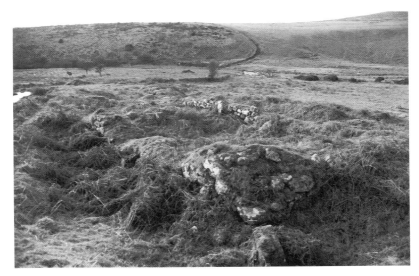

The scanty ruins of the dwelling house at one of the three Piles tenements, all of which had been abandoned for human habitation before the beginning of the 18th century (November 4th).

7th **1835.** An advert in the *Mining Journal* calls for applications "from parties desirous of setts, to search for tin and other metals, within lands belonging to the Duchy of Cornwall", applications to be made to the Duchy Hotel, Prince's Town.
1873. Richard Andrews and William Smerdon are each paid 3s 8d (approx 18p) for two days work "in Awsewell Taking Down Larch for Capt Browning". The latter probably refers to Captain Richard Browning of East Birch Tor Mine.

8th **1886.** William A. Grose is born in a remote cottage in Cornwall. Later working at Atlas, Owlacombe and Hexworthy Mines, he lived to be nearly 108 years old!

9th **1889.** William Symons is buried at Lydford, in which village he had been the schoolmaster for a remarkable 62 years.

10th **1762.** Thomas Windeat of Moretonhampstead, fellmonger, leases to John Bridgman of Moretonhampstead, clothier, all the messuages and houses etc "lying near the flesh Shambles in the Town Borough and parish of Moreton". The rent is £10 per annum.

11th **1825.** A 21-year lease of the Fillice Down Mining sett is granted to John Collier.

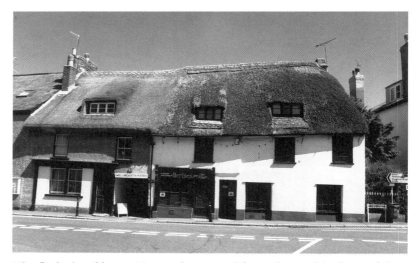

The flesh shambles at Moretonhampstead formerly stood in front of these cottages, and the adjacent ones, just off the square in the centre of the town (q.v. November 10th).

1941. Various premises are opened in the parishes of Brentor, Lydford, Mary Tavy, Horrabridge and Yelverton, where locals can collect their 'Food Ration Books RB10'.

12th **1889.** A list of prices comprising the "Schedule of Tolls to be taken at the Annual Fairs and other times at South Brent" is painted on a slim wooden board. The board still hangs on the front of the little market tollhouse in Church Street, South Brent.

1910. Some prices of foodstuffs sold at Ashburton Market, as reported in the *The Western Daily Mercury:* butter 1s 2d per lb, eggs 1s 8d per dozen, geese 10d per lb, beef 8d per lb, potatoes 8d for 20lbs, parsnips 1d per lb, cauliflowers 2d each, apples 2d per lb.

13th **1936.** A letter from the Reverend L. Sleeman of 11 Cadogan Square, London, asks the Maristow steward to let him know of the 'bags' of the previous two days' shoot, "for I have not missed a days entry in my game book for certainly 40 years or more". The reverend also says that he enjoyed the shoot "in spite of the filthy weather".

14th **1816.** A special general meeting of the Wheal Friendship Company is held at Bakers Coffee House, Cornhill, London. To settle part of its £3,000 debt owed to bankers Gill & Co a call of £30 per 1/64th share is made.

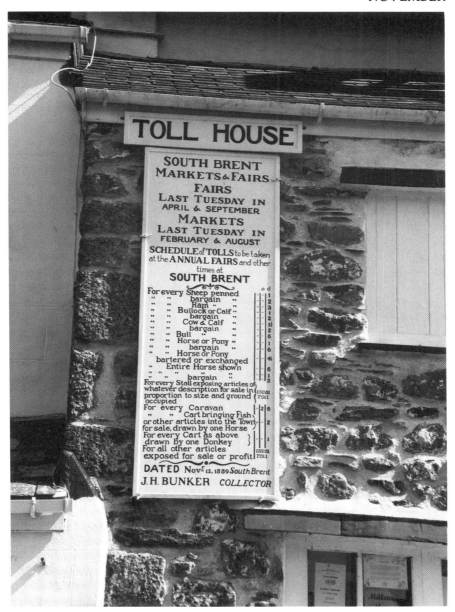

An original market toll board still hangs outside the little tollhouse in South Brent (q.v. November 12th).

The principal surviving ruins at Wheal Friendship are the arsenic condensers of its later period of operation (q.v. November 14th).

1985. Athelstan Cornish, son of W. H. Cornish of Black Rock, Buckfastleigh, dies at Totnes. His memorial in Buckfastleigh churchyard records that he had previously been the chief mechanical engineer on the North Western Railway in the Punjab.

1997. At a special book launch to mark the 150th anniversary of William Crossing's birth, held at the Plume of Feathers, Princetown, Forest Publishing releases *Folklore and Legends of Dartmoor*, a compilation of the writer's series of newspaper articles under the same title.

15th **1551.** King Edward VI impropriates the tithes of Ugborough Church and leases them, and the patronage, to Arthur Champernoun for a yearly rent of £8, the term to begin upon the death or resignation of the incumbent. (Rector Adam Travers died in 1555, when the patronage of the rectorship passed into lay hands, and succeeding incumbents were thus vicars.)

1765. The Widecombe overseers expend 14s (70p) "To Clothing Margaret Ruby's Base Daughter Bound Apprentice to Thos. Layman of Huckaby". That the tenants of the ancient tenements of the Forest – of which Huccaby is one – resorted to Widecombe Church, even though the properties are situated in Lydford Parish, is well documented. This, and similar entries in the Widecombe records, suggests that the properties might also have been

considered as being in Widecombe Parish for the purposes of administering the poor laws, including assigning apprentices and resolving issues related to settlement etc.

1918. An extract from the Harford School logbook indicates how slowly news of major national importance filtered through to secluded hamlets, even in the early 20th century – "On hearing the Armistice had been signed Monday 11th, stopped lessons and sang the National Anthem at a quarter past three". (This is still rather puzzling, for a similar entry in the school logbook of neighbouring Cornwood records that, on the day in question, November 11th, "Shortly after assembly I heard the sirens and hooters of Plymouth sounding...I anticipated that they signalled the acceptance by Germany...for an armistice".)

16th **1802.** Having previously rescinded a small piece of its land to Okehampton over the disputed burial of a stranger found dead at Iron Gates, Sourton evidently intended that a similar incident would not arise again, as indicated by this entry in the registers – "16th Nov 1802 Was Buried the body of a Stranger found dead on Dartmoor after a Coroners Inquest, he appeared to be about 44 years of age and from items found in his pocket and upon enquiry he appears to be Benjamin Hardridge late of Broadstreet point Portsmouth Hants".

17th **1727.** In his will William Candy of Ilsington leaves property and money to, amongst other things, buy annually for "nine poor Men of this parish [of sober Life and Conversation and resort duly to the parish church on the Lords-day and do not receive any Monthly Relief from the parish]" a new hat, coat, shirt and pair of shoes.

18th **1256.** Roger de Teynton grants Drogo de Teynton one ploughland in Forsham in return for a reciprocal grant of one ploughland in Teynton (Drewsteignton). As part of the exchange, Drogo has to pay Roger a pair of white gloves every Easter.

19th **1910.** *The Western Daily Mercury* advertises for sale a large amount of mining equipment, the property of the Ramsley Exploration Syndicate Co Ltd (Ramsley Mine, South Zeal), to be auctioned by Peter Hamley & Sons, upon the instructions of the liquidator of the company, W. G. Roberts.

20th **1630.** Bennet Peterfeyld pays the Buckland Monachorum receivers 8s 6^1/2d (approx 42^1/2p) for "farme Tinne of the parish workes".

21st **1524.** John Cole of Slade fails to appear before the tax commissioners to answer a charge "ffor that he was suspected by

Philip Champernon Andrew Hyllersdon and Henry Fortescue commissioners for the taxacyon of the kings subsedy to be of more and grett substance yn goods than he was presented by the presenters...and he was warned by the bayle...to appere...to be examyned of the same". What happened after John Cole's non-appearance is uncertain, although it is known that a wealth in goods to the value of £120, which John Cole declared for the lay subsidy of 1524, was increased to land valued at £133 in the roll of the succeeding year.

1821. Peter Tavy Church receives "material injury from a tremendous storm of lightning and thunder", the results of which leave the tower and church "lamentable spectacles of the Judgements of God", as a contemporary report in the parish register records.

22nd **1522.** In his will John Wescote of Chagford bequeaths a half share in a tinwoks called South Kyngesmyth to John Reffe. The site of the works is thought to be somewhere near the King's Oven.

1792. At a meeting in the White Hart Inn, Moretonhampstead, to establish the charges for the newly-established postal service in the town, the parishioners resolve that "one penny be charged on every letter delivered out of the office and that the letters received into it shall pass free".

23rd **1866.** William Staplin, a journeyman machine maker, brings a suit against Philip Veal, wheelwright of Walkhampton, claiming a debt of £5 10s (£5.50p) for the balance owing on seven reaping machines. The case is dismissed, the magistrate observing that Staplin had already received all that was due to him.

24th **1820.** The Wheal Friendship Committee agree to give £100 to the Tavistock Turnpike Trust, "for the repairing of the new turnpike road from Lanehead to Tavistock". This, amongst other archive references, provides firm evidence for the correct historical site of the locality name Lanehead (the junction at the Mary Tavy Inn), which on present O.S. maps is incorrectly assigned to a spot some three miles distant.

1853. Amos Shillibeer is paid £6 for "tracing & marking out the line of Boundary between Walkhampton Commons and Dartmoor Forest from Aylesborough to Great Mistor".

25th **1269.** Robert Knoel grants lands in Maneton to Robert le Deneys, together with "all messuages, demesnes, homages, rents, services of free men, villenages and the villeins belonging to them, wards, reliefs, escheats, woods, meadows, pastures, waters, ponds and

The scene in the Chapel of St Lawrence on what is known as Ashburton Law Day, when the ceremony is held at which the portreeve for the succeeding year is formally appointed and sworn in (q.v. November 28th).

mills" belonging to the same.

26th **1698.** Walter Symons and Grace Goodwin are married in Tavistock. Or are they? Rather oddly, the same marriage entry appears on the same date in the Peter Tavy registers, which entry describes the couple as "both poor labourers of Tavistock".

27th **1858.** William Nicholas becomes the new landlord at the Whitchurch Inn. His rent is set at £12 per annum.

1886. Sir Massey Lopes grants a 44 x 80ft plot of land "situate near Foggintor in the parish of Walkhampton adjoining to and on the North side of the road leading from Moretonhampstead to Tavistock and opposite the road leading to the Princetown Quarries and the Red Cottages" for the building of a place of worship, which was later to become known as the Foggintor Mission Hall.

28th **1817.** John Pearse of Ashburton swears on oath that "the entry in the parish register made June 8th 1766 is false, and should be altered thus: Mary daughter of George Whiteway & Grace his wife". The original baptism entry recorded the parents' names as Richard and Grace Whiteway.

2000. The portreeve for the year ensuing, 2001, is appointed at a ceremony in the Chapel of St Lawrence, Ashburton, the 1,181st member of the local community to hold this ancient office (the first portreeve of Ashburton was appointed in AD 820, and one has been appointed annually ever since). Chris Monnington (who had also served as portreeve in the year 2000), and his new bailiff, Paul Knowles, are appointed and sworn in during a ceremony which has remained essentially unchanged for countless centuries.

29th **1866.** The Whitchurch vestrymen ask their chairman to "put himself in communication with Mr Barrington the Sub agent of the Duchy stating the remonstrance of the parishioners against an agreement already made for the granting of a lease to Mr George Knowling for the Building of a house on the Commons Land belonging to the parish of Whitchurch requiring him to withdraw such agreement or if persevered the parishioners will resist such encroachment".

30th **1578.** Nicholas Slanning, lord of the Maristow Estate, is granted a licence by Jerome Mayhowe of Boringdon to construct a weir across the River Walkham at Byklym (Bicklime) Wood, Sampford Spiney, in order to provide water power for his mill at Hokeford (Huckworthy) Bridge.

✳✳✳✳✳

December

1st **1893.** The Reverend William H. Carwithen, aged 82, resigns as rector of Manaton, the last of nine generations of Carwithens who were rectors of the parish.

2nd **1864.** R. Dennis of the Old Delabole Slate Depot, Tavistock, advertises for sale vast quantities of slate artefacts which he had recently "purchased for cash of the Old Delabole Slate Co at their reduced rates". On offer are various items such as roofing and flooring slates, window cills and door steps, dairy benches and also headstones and tombstones. Doubtless a number of Delabole slates of the period still stand in the graveyards of the neighbouring Dartmoor border parishes, and, perhaps, earlier headstones in the district were also made of prime quality slates from this well-known source.

3rd **1969.** An auction of what are described in bill posters as 'mansion furnishings' takes place at Fardle Manor, Cornwood.

4th **1780.** During this period of history many were buried in places far from their native towns or villages, and one wonders how, or even if, their relatives received notice of their deaths and their final resting places. On this day John Hanson of the Yorkshire Light Dragoons is buried in Tavistock.

1828. Charles Corbyn Wills loans £100 to Ilsington Parish for the building of two cottages at Firchins Cross for the use of the poor.

5th **1809.** The will of Elias Andrews of Buckland-in-the-Moor leaves Stone Farm to his son-in-law, William Norrish. This bequest, of the most valuable freehold property in the parish (excepting Buckland Court itself), was a very mixed blessing, for it led, ultimately, to the collapse of the Norrish family fortunes a generation later. The reason, the bequest was "subject nevertheless to the payment of Four Hundred pounds now charged thereon" – in other words, the property was mortgaged to the hilt.

1830. In the post-Napoleonic depression rural parishes across the nation are fighting a losing battle in vain attempts to combat poverty and pauperism. The minutes of a meeting held on this day in Ugborough are typical of the commentaries of the period, a meeting called "for the purpose of taking into immediate Consideration the most speedy and permanent method of

relieving and lessening the deplorable degree of pauperism and distress under which the Agricultural Labourers and others are now suffering Arising from the impoverished Condition of the tenant farmers & the Consequent deficiency of employment".

1895. All the machinery and equipment of Hexworthy Mine, opened only six years earlier, is advertised for sale by auction. The lease on the mining sett was surrendered four weeks later. It was reopened in 1905, and was then worked, intermittently, for about ten years or so.

Ruins at Hexworthy Mine (q.v. December 5th).

6th **1634.** Justices Sir Edward Gyles, Sir Richard Reynell, Thomas Ford and Richard Cabell issue a warrant to the constables of Yealmpton to levy 7s 4d (approx 36$\frac{1}{2}$p) against the parish rates towards repairing "the decayes of Dart Bridge & church bridg in the pishes of Ashbton & Buckfasleigh". Constables elsewhere would have been issued with similar warrants to levy sums proportionate to the number of inhabitants within their parishes.

7th **1652.** The overseers of East Allington covenant to pay for the upkeep of Allice Scoble and her children, living in Ugborough, should they ever become chargeable to the poor rates of the latter parish.

8th **1610.** John White names John Stidston and Roberte Foster as his

attorneys in his marriage settlement conveying Bulhorneston in South Brent to Ellen Luscombe "in Consideration of a marriage to be solempnisede by and between...[them]...in recompense of her Dowrye".

1940. The Ugborough headstone to Dorothy M. Hutchinson, who died on this day, records that she was the "First Lady church-warden of this parish". Ugborough was around four centuries behind Ashburton, where women served as churchwardens at least as early as Elizabethan times.

9th **1801.** John Andrews, solicitor of Modbury, requests counsel's opinion on the terms of the will of Elizabeth Bickford of Ugborough, and the position of the principal beneficiary, Henry D. Hodge. The reply from G. N. Neyle of the Lincolns Inn, dated this day, is typically incomprehensible! – "I am of the opinion...that Mr Hodge may bar the Estate Tail & Remainders over and acquire a fee simple by being vouched in a Common Recovery...the Limitation to Trustees to preserve contingent Remainders, are certainly indicative of the Testator's Intention that Mr Hodge should have only an Estate for Life".

10th **1612.** John Stonier becomes the new tenant at the tucking mills at Bridge, Buckland-in-the-Moor. His rights include permission for

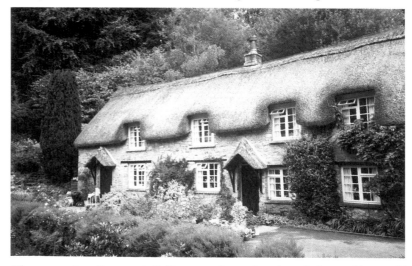

The present cottages at Bridge stand on the site of the tucking mill tenanted by John Stonier in 1612, a building which was destroyed in a fire in the 1690s (q.v. December 10th).

"the standing of Reckes [racks] in Burch and Begley with free Ingress Egress and Regress with...all needfull and necessary Carriages...for...Carryinge of Reckes Cloth and Clothes and all other necessaryes".

1769. Walter Radcliffe leases South Godsworthy, Peter Tavy, to Roger Chubb. In a clause customarily included in all manorial leases of the period, Chubb also covenants to "Execute the Office of Reeve Bailiff or Tithingman of the said Manor as other the Tenants thereof do or ought to do in respect of their being Tenants of the same when thereto appointed".

11th **1885.** The *Tavistock Gazette* prints a full list of MPs in the 'Reformed Parliament', the first to be elected under the Representation of the Peoples Act 1885. Amongst the Devon MPs are two from Dartmoor boroughs – C. S. Hayne, representing Ashburton, and Viscount Ebrington, representing Tavistock, both Liberals.

12th **1935.** Mary Tavy Parish is absolved forever from paying an annual rent of assize of 4d (approx 1¹/₂p) to the Duchy of Cornwall for a tenement named in the Certificate of Discharge as "church Land Part Pellows within the Borough of Lydford Parcel of the Possessions of the Duchy of Cornwall".

13th **1779.** A "remarkable awful event", as described in a contemporary account written in the register, occurs at Manaton, when a violent storm wreaks terrible damage to the church, demolishing the east front, tearing one of the pinnacles from the tower and sending the bell frame crashing through the roof of the nave.

1800. Edward Shapter of Cornwood, chief constable of the Ermington hundred, orders all parish constables within the hundred to produce a "...fair list in writing of the names of all the men usually...Dwelling within your parish...between the atges of Eighteen and forty five years..." and who are liable to serve in the Militia, such lists to be presented to the deputy lieutenant of the county at the New Inn, Modbury, on January 22nd 1801.

14th **1838.** An application by the newly-formed Plympton St Mary Poor Law Union, of which Cornwood is now a part, to sell the three houses next to Cornwood churchyard which had been used as the poor house, is approved at a meeting of the parishioners.

1931. Reporting on the funeral of Richard Pengelly, last moorman of Combeshead, the *Western Morning News* records that "From the cottage, which is situated beneath Down Tor, high up the valley leading to the Burrator Reservoir, the funeral procession had necessarily to go slowly, because streams and boulders had

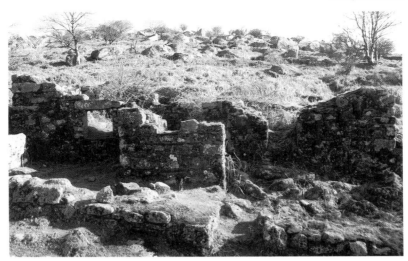

The ruins of Richard Pengelly's little cottage at Combeshead (q.v. December 14th).

frequently to be surmounted".

15th **1830.** In a competent hand, John Chaffe of Menheniot writes a letter to the Ugborough overseers appealing against a removal order and asking them to "give my case your earliest consideration & allow me such weekly sum that I may be enabled to support myself and wife. I doubt not but that the overseers of this parish would on your Sending a written request, advance me such weekly sum as you may think proper". At the time John Chaffe is suffering from asthma and water on the chest, and unable to work, as a signed affidavit from the minister of Menheniot and a local surgeon records. The appeal goes un-heeded.

1924. Twenty-one-year old Ellen Kate Belchar, daughter of the postmaster at Shaugh Prior, is drowned near Cadover Bridge whilst on her postal round.

16th **1777.** Christopher Furneaux, blacksmith of South Brent, becomes the owner of "one Messuage six Acres of land four Acres of meadow six Acres of Pasture six Acres of ffurze & Heath & Comon of Pasture with the Appurtenances in Hills Britchaland & Broadmoor", all part of Bullhornstone (named Bulson in the deed), conveyed to him by William Mann, trustee of the will of Margery Bulley of Ipplepen.

17th **1840.** W. J. Stentaford is paid for measuring and mapping Walkhampton Parish for the Tithe Commutation Act.

18th **1828.** The Reverend James Holman Mason writes to Thomas Leaman of Tiverton on the subject of tithes of the Forest, referring also to Leaman's tenant, Richard Tuckett of Dunnabridge. Quite unrelated research has established that Leaman, a solicitor, was also the leaseholder on Stenlake, Walkhampton, where George Conybeare was his sub-tenant. It may well be that he held other interests on Dartmoor.

1914. The Cornwood School logbook records that the teachers and girls have knitted 12 pairs of mittens, 10 pairs of socks, 8 sleeping caps, 9 scarves, 11 body belts and 2 girdles for soldiers on the Western Front.

19th **1762.** A small docket in the Ugborough collection records that the overseers expended nearly 5s (25p) attending to a stranger who fell sick in the parish and then, presumably tiring of his presence and the drain on parish funds, on this day paid him 1s 6d (7^1/2p) "In Cash to putt in his Puckett to send him away"!

20th **1837.** George Giles, Maristow manor steward, writes to the Reverend John Abbott of Meavy mooting the idea of building a bridge over the Callisham Brook, the cost to be shared between the landowners in the vicinity.

21st **1866.** The *Tavistock Gazette* reports on the inquest into the death of stoker William Dawe, killed in a railway accident at Horrabridge Station during the previous week. The unfortunate victim is reported to have fallen between the train and the platform whilst standing on the splashers throwing sand on the rails to stop the wheels slipping. (This was standard procedure on a train drawing out of a station.) The engine driver did not know that he had fallen until the station porter alerted him, by which time six or seven trucks had run over the stoker.

22nd **1882.** The Christmas fare on sale at Tavistock meat market this year includes a Devon ox weighing 7cwt, some prime Dartmoor wethers, a Shorthorn heifer weighing 10cwt, two Devon steers weighing 13cwt each, a South Hams heifer weighing 7^1/2cwt, some Exmoor wethers weighing 17lbs per quarter and a selection of geese, ducks, fowls, hares and rabbits.

23rd **1953.** Posters advertise a nativity play to be held on this day in the church at North Bovey – an event which will not strike readers as in the least unusual or remarkable. What is remarkable, however, when considered against the background of present-day concerns

about the lack of public transport in rural areas, is that the posters also proclaim that a bus will be laid on specially to bring Chagford and Moretonhampstead inhabitants to the play – and, more particularly, that one will also arrive to take them home again!

24th **1878.** In a court case concerning a brawling incident in Ugborough, PC Pope reports that he first discovered the defendants, James Ryder, James Hurrell and William Coker, scuffling with the landlord of the Anchor Inn, whereupon they were ejected. Some hours later he found them fighting in the street. The next part of PC Pope's statement must have raised a few eyebrows on the bench, for he casually observed that he was "surprised to find that they were all on top of my son"!! The three were then arrested for being drunk and disorderly. No further mention is made of the son, so presumably he escaped!

25th **1667.** William Bastard, lord of the manor of Buckland-in-the-Moor, leases to Leonard Leayman "all that one Plott of grounde Called or knowne by the name of Oke more Contayning by estimacon six acres or thereaboute be it more or less situate Lying and being in the pish of Buckland".

26th **1713.** George Wills, yeoman, and Henry Brock, miller, sell to John Wills, yeoman, "All that the Moyety or halfendaele of all those Messuages Lands & tenemts...of Hurston...togeather with common

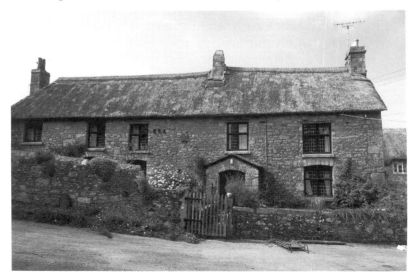

The farmhouse at Hurston (q.v. December 26th).

123

of pasture on Hurston Ridge & Bovey Combe..." for £66. Also conveyed with the property are "true Coppyes of all other deeds writeings & evidences touching the sayd prmisses".

27th **1645.** The future king, 15-year old Prince Charles, arrives in Tavistock to rally royalist forces. It is said that the visit made a lasting impression, and that he was to observe some 20 years later that "it is always raining in Tavistock"!

1699. The churchwardens and overseers of Meavy issue a settlement certificate to Robert Bouden and his family, which will allow them to live in Ugborough "for theire better Livelyhood and maintenance". Like all such certificates, this one acknowledges the family to belong to Meavy, and covenanted to take them back to Meavy if they ever became chargeable to the Ugborough poor rates.

1790. A payment of 6s 2d (just over 30p) is paid by the Buckland-in-the-Moor highway surveyors for erecting two "diricting posts". Only one of these survives, standing at Stone Cross, and it is the only dated guide stone on Dartmoor.

28th **1619.** Henerie Burt and Eulalia Marsh are married in Dean Prior. They sail for America shortly afterwards.

29th **1780.** William Crossing, amongst others, refers to a (now lost) headstone in Holne churchyard to Ned Collins, which had an unusual epitaph recording, amongst other things, that poor Ned had been laid "On his last Mattrass bed". It seems that no previous author has recorded the date of burial. All can now be revealed! From the Holne registers: "29th Dec 1780 Edward Collings was buried".

1815. Richard Willis of Ugborough joins the 43rd Regiment of Foot. He served for 17 years until, in 1832, he was court-martialled for "disgraceful and infamous conduct".

1994. A bolt of lightning strikes the tower of Brentor Church, causing serious damage.

30th **1893.** The Reverend William Marle, vicar of Sourton, is buried in the graveyard there. He had been the first student to gain a degree in theology at Balliol College, Oxford.

31st **1305.** Thomas, Bishop of Exeter, grants the church at Walkhampton to the use and benefit of the abbot and convent of Buckland.

1584. Amongst the items recorded in the inventory of the goods and chattels of Richard Widdicomb, late of Buckland-in-the-Moor, are the following livestock: "Tenne oxen £23, 7 kine £9, 12 young

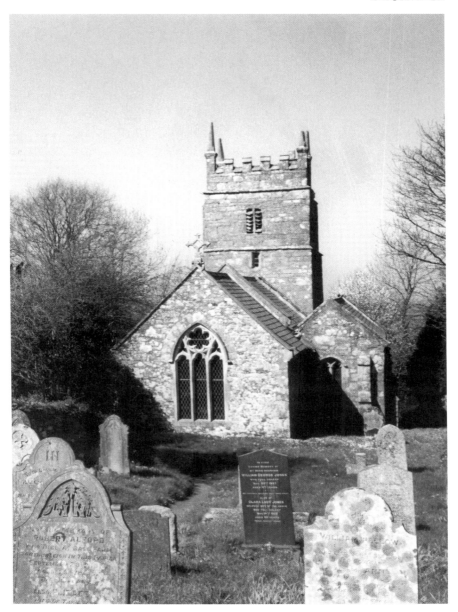

The Church of St Thomas à Becket, Sourton, and part of the graveyard where the Reverend William Marle is buried (q.v. December 30th).

bullokes and 4 calves £12, 3 labouring beastes and two coltes £5, One hundred sheepe £13 6s 8d, 4 hogges and swine 20s, geese and pultrie 6s 8d".

1840. A public meeting for the commutation of the tithes of Walkhampton is held at the Maristow Inn, Doustiland.

1999. To celebrate the eve of a new millennium, a thousand or more people gather on the summit of Hey Tor for the lighting of the Ilsington Parish millennium bonfire.

✱✱✱✱✱

List of Subscribers

Sandra & Chris	Torquay, Devon.
Mrs Patricia J. Ackland	Beeches, 105 Sandygate Mill, Kingsteignton, Newton Abbot, Devon.
Nan Adams	7 Courtfield, Totnes, Devon. (4 copies)
Martin Alexander	3 Orchid Vale, Kingsteignton, Devon.
Mr Jem Allaway	13 Culver Close, Bradninch, Exeter, Devon.
Norman J. Allen	2 Maymar Terrace, Whiterock Road, Wadebridge, Cornwall.
R. G. Amson	91 Hessary Drive, Roborough, Devon.
Mr & Mrs R. Andrews	Berescott, Roborough, Devon.
Richard & Veronica Andrews	5a, Six Acre, Pathfinder Village, Exeter, Devon.
Peter Ashby	10 Knowle Close, Cullompton, Devon.
M. A. K. Ashfold	Higher Quarry Farm, Moortown, Tavistock, Devon.
Mr John Bailey	3 Penlee Street, Penzance, Cornwall.
Mr & Mrs K. Bailey	29 Main Ave., Daison, Torquay, Devon.
L. H. G. Bailey	Torquay, Devon.
Mrs Sybil M. Ball	'Rudgewick', 9 Clonway, Yelverton, Devon.
Michael Banyard	77 Ratcliffe Road, Farnborough, Hants.
Derrick Baragwanath	80 Grenville Road, St Judes, Plymouth, Devon.
Mr N. Barber	25 Spring Grove, Fetcham, Leatherhead, Surrey.
Mr & Mrs Peter Barker	Sea Meadow, Charmouth, Dorset.
F. G. Barlow, B.E.M.	22 Northfield Road, Okehampton, Devon.
The Barnes Family	Wormit, Fife.
Mr D. Batehup	
Mr Jorg Beasley	Yeoford, Devon.
Pauline Bedborough	11 Higher Longford Farm, Moorshop, Tavistock, Devon.
Caroline F. Belam	The Strole, West Buckfastleigh, Devon.
Richard K. Bennett	52 Briar Rd., Hartley, Plymouth, Devon.
Stewart Bergman	2 Margaret Road, East Ogwell, Newton Abbot, Devon.
Phil & Bev Bishop	10 Westaway Road, Colyton, Devon.
Roy Blank	Paignton, Devon.
Margaret Blowey	Mount Tavy, Tavistock, Devon.

Alan Boon	14 Rock Park, Ashburton, Devon.
Terry Bound	3 Alpha Street, Heavitree, Exeter, Devon.
(d.o.b. 25th March 1940)	
Mrs S. Boustead	Newton Abbot, Devon.
Mrs Patricia Jonquil Bradbury	Barnfield Road, Paignton, Devon.
Mrs Jean Bradshaw	Larwood, 13 Higher Street, Cullompton, Devon.
Rhiannon, Keith & Peter Bragg	25 Moor End, Holyport, Berks.
Gordon Bray	Sussex.
Dave Brewer	Meopham, Kent.
Kath Brewer	Barton, Torquay, Devon.
Brian Britten	Plymouth, Devon.
Ray & Anne Brooking	Warick House, Crownhill Road, Plymouth, Devon.
Charles & Caroline Brown	Healdsburg, California, U.S.A.
Maureen Brumby	9 Well Gardens, Plymouth, Devon.
Hazel M. Burke	Marldon, Devon.
K. J. Burrow	Bucks Cross, Devon.
Bob & Jan Callicott	Yate, Bristol.
Richard & Sue Callow	The Rock Inn, Yelverton, Devon.
Dennis Camp	Plymouth, Devon.
Denis Carnaby	Woodfield Lodge, Torwood Gardens Road, Torquay, Devon.
Joan Carpenter	98 Avenue Road, Torquay, Devon.
Aileen & Peter Carrett	Liverton, Newton Abbot, Devon.
John Carter	High Hurlands, Liphook, Hants.
Kristian Carter	Warminster, Wilts.
Patrick Cashell	Brook Cottage, Peter Tavy, Tavistock, Devon.
Nicholas Casley	Peverell, Plymouth, Devon.
Michael Caton	Wylde House Cottage, Ledbury, Herefordshire.
Hazel Chapman	Park Hill House, Old Mill Road, Chelston, Torquay, Devon.
J. W. Chase	72 Parkside Drive, Exmouth, Devon.
Mr Mike Christophers	Pound Cottage, Pound Street, Moretonhampstead, Devon.
Mr R. J. Clark	22a Haldon Ave., Teignmouth, Devon.
Ms Jeanne Clutten	Nottingham.
Codsall Cookies	3 Meadow Way, Codsall, Wolverhampton, West Midlands.
Mr D. W. Cole	Paignton, Devon.
George Colton	Cornwood, Ivybridge, Devon.
Margaret Cook	Tavistock, Devon.
Mr Reg Coombes B.E.M.	Summerhayes, 31 Essa Road, Saltash, Cornwall.

Mr P. D. Couch	Plymdene, 127 Hamlin Lane, Heavitree, Exeter, Devon.
J. Coulthard	Horrabridge, Devon.
Maurice W. Criddle	Teignmouth, Devon.
Mrs M. Dancer	228 Ermin St., Lower Stratton, Swindon, Wilts.
Joy Dancey	4073670 Banff Court, North Vancouver, B.C.
Dartmoor National Park Authority	
Ken & Gloria Davey	Plympton, Devon.
Keith Dawes	Victoria Villa, Victoria Terrace, Clifton, Bristol.
Mr M. Dennison	12 Combley Drive, Thornbury, Plymouth, Devon.
Devon Library Services	(10 copies).
G. E. Diggines	Paignton, Devon.
G. J. D. Dollard	Delamore, Cornwood, Devon.
Mr B. Domoney	277 Oborne Road, Sherborne, Dorset.
David Alexander Duffield	3 Highertown, Horrabridge, Nr. Yelverton, Devon.
Mrs Shelagh Duffy	Belleair, Lower Woodside Rd., Wootton Bridge, Ryde, Isle of Wight.
Robert Earl	44 Lalebrick Rd., Hooe, Plymouth, Devon.
David & Josephine Edge	Mill Brook, Liverton, Devon.
W. J. Edmunds	Gribblesdown, South Brent, Devon.
Jeff Edwards	114 St. Peters Rd., Brake Farm, Plymouth, Devon.
Mr & Mrs H. Ekers	Totnes, Devon.
Shirley & Bob Elliott	Windmill Lane, Northam, Devon.
Jim & Mar Evans	103 Butt Park Road, Plymouth, Devon.
Ray Evans	Bournemouth, Dorset.
Mr Stephen A. Ferren	46 Rolston Close, Tamerton Vale, Plymouth, Devon.
Mr Richard Field	'Tooleys', Tamerton Foliot, Plymouth, Devon.
Ted Fitch	2 Park Road, Dartington, Totnes, Devon.
Mr & Mrs V. P. Frendo	Briarwood, 66 Copland Meadows, Totnes, Devon.
Jason Frost	'Sittaford', Burroughes Avenue, Yeovil, Somerset.
W. E. & R. A. Furneaux	Buddle Farm, Broadwoodwidger, Devon.
Dr Christopher Gardner-Thorpe	The Coach House, 1a College Road, Exeter, Devon.
Alan & Gill Garland	90 Burley Grove, Downend, Bristol.

S. Gawman	Horrabridge, Devon.
David & Rosemary Glanville	3 Lashbrook, Talaton, Exeter, Devon.
M. H. Goodall	58 Rymond Road, Birmingham.
Dave & Jenny Goodman	South Molton, Devon.
Dr Tom & Mrs Elisabeth Greeves	Tavistock, Devon.
Mrs Stella Grimsey	Overton, Hants.
Barbara Groves	Penryn, Cornwall.
Mrs D. B. Hall-Say	Liftondown, Devon.
Linda & Alan Halpin	
Peter R. Hamilton-Leggett, BSc.	Walkhampton, Devon.
G. Hamilton-Sharp	Dorchester, Dorset.
Mr Glenn M. Hannigan	'Woodmead', Tavistock, Devon.
C. D. & M. E. Harris	6 Parklands, Okehampton, Devon.
Mr G. Harris	
Mr & Mrs L. J. Harris	Torquay, Devon.
Mrs Shirley Harris	Paignton, Devon.
William Hart	Lower Knowle, Lustleigh, Devon.
Mr & Mrs R. A. Hayes	The Shieling, Shaugh Prior, Devon.
Peter & Mary Head	Shute House, Denbury, Newton Abbot, Devon.
Mrs E. J. Hebblethwaite	
Mr M. S. Herbert	Rose Cottage, North Whilborough, Newton Abbot, Devon.
David & Hazel Hill	Kington, Herefordshire.
Robert Hill	Wokingham, Berks.
A. R. Hiscox	20 Mannings Meadow, Bovey Tracey, Devon.
G. T. Q. Hoare F.I.M.A., C. MATH.	3 Russett Hill, Chalfont St. Peter, Bucks.
Melenie Hooper	Haselbury, Plucknett, Somerset.
Mrs Patricia Horrell	Plymouth, Devon.
R. Horsham	Middlezoy, Somerset.
Dennis S. Hounsell	8 Hyde Park Road, Mutley, Plymouth, Devon.
Mrs Anne Howse	7 Wolborough Gardens, Newton Abbot, Devon.
Mr J. R. D. Howse	'Newhaven', South Furzeham Road, Brixham, Devon.
Christopher P. Humphries	Launceston, Cornwall.
Mrs Margaret Huzzey	4 Woodchurch, The Crescent, Crapstone, Yelverton, Devon.
Ken Isham	St. Austell, Cornwall.
Annette & Derrick Jefferies	Saul, Gloucester.
Sandra & David Johnson	Chelston, Torquay, Devon.
Miss B. D. Jordan	94 White Post Field, Sawbridgeworth, Herts.
Ron Joy	61 Grenville Drive, Tavistock, Devon.

Chris Kelland	12 Northumberland Place, Teignmouth, Devon.
Colin C. Kilvington	Stoke, Plymouth, Devon.
E. M. & P. C. King	Segura, Diptford, Devon.
Stewart Kington	A Dartmoor Witness
Major R. F. Kitchin	Withill Farm, Walkhampton, Devon.
Chris Klinkenburg	Chorley, Lancs.
David J. Lambert	5 Abney Crescent, Roborough, Plymouth, Devon.
Wendy Lamble	Totnes, Devon.
Mr Paul Lane	30 Penrith Gardens, Estover, Plymouth, Devon.
Mike & Karen Lang	Woodstock, Liverton, Devon.
Rachel Lang	Woodstock, Liverton, Devon.
Mrs M. G. Lauder	19 Manor Park, Dousland, Yelverton, Devon.
J. Lee	Tavistock, Devon.
Joan & Maurice Lee	15 Landhayes Rd., Redhills, Exeter, Devon.
Ron Leighton	Sidmouth, Devon.
Dr M. & Mrs P. Lekis	17 Heathfield Close, Bovey Tracey, Devon.
Robin H. Limmer	Mill House, Broome, Norfolk.
D. A. Lissenden	26 Frobisher Drive, Saltash, Cornwall.
Local Studies Dept.,	Plymouth Central Library.
Mr Edwin Lovegrove	Uckfield, East Sussex. (Formerly of Brixton, Devon)
Barry & Patricia Luckraft	7 Falkland Way, Teignmouth, Devon.
Mr Philip W. Luscombe	50 North Down Crescent, Plymouth, Devon.
Mr & Mrs G. Lyall	17 St Cleres Way, Danbury, Chelmsford, Essex.
Mr & Mrs M. H. Lyall	4 Oak Drive, Burghfield Common, Reading, Berks.
M. P. McElheron	Kingskerswell, Devon.
Mrs I. McEwen	61 Uplands, Tavistock, Devon.
Chris McIntosh	Shanklin, Isle of Wight.
Dr Angus McKay, MCSM	Sun Cottage, Tarrandean Lane, Perranwell Station, Truro, Cornwall.
Patrick McQuillen	Royal Oak Farm, High Hurstwood, East Sussex.
Mr Patrick Maher	Ottery St. Mary, Devon.
Douglas & Gill Marsh	Chagford, Devon.
David & Pauline Marshall	Pentland Close, Southway, Plymouth, Devon.
Nick Martin	8 Swallowcliffe Gardens, Yeovil, Somerset.
Robert Martin	Ogwell, Newton Abbot, Devon.
Helena Mathew	Torquay, Devon.
Clive & Pam May	91 Davies Avenue, Whiterock, Paignton, Devon.
John Maynard	31 Merafield Drive, Plympton, Plymouth, Devon.

Brian & Christopher Mead — Fardel, Cornwood, Devon.
Pam & Alan Meridew — South Brent, Devon.
Lt. Col. & Mrs R. A. Middleton — Fair Winds, Southella Road, Yelverton, Devon.
Doreen Mole — Plymouth, Devon.
Chris Monks — 51 Vicarage Rd., Whitehall, Bristol.
Sylvia & Tony Moore — 25 Sanderspool Cross, South Brent, Devon.
Y. M. & J. P. Moore — 113 Morton Terrace, Gainsborough, Lincs.
Margaret Morley (neé Hannaford) — Iwerne Minster, Dorset. (2 copies)
Arch & Audrey Mortimore — Grattons, Widecombe-in-the-Moor, Devon.
Dr S. A. Mucklejohn — Wigston Magna, Leicestershire.
Mary Myers — Dorchester, Dorset.

Heather & Bill Newcombe — 32 Tadworthy Rd., Northam, Devon.
Bob Noakes

Mr & Mrs P. O' Doherty — Banbury, Oxon.
Lorraine O' Sullivan — 4 Big Lane, Lambourn, Berks.
John Odams, F.R.G.S.
Barbara Oliver — Blossom Villa, Vale of Health, London.
Mary Osborn — Yelverton, Devon.

Andy Pain & Liz Hussell — Peartree Cottage, Spetisbury, Blandford, Dorset.
Len & Sharon Paramore (Torpoint Trekkers) — 84 Woodland Way, Torpoint, Cornwall.
David Parnall — Plymouth, Devon.
Dr. Geoffrey Parnell — Maldon, Essex.
Mike & Jane Passmore — Exeter, Devon.
Margaret Pearce — 5 Colmer Road, Yeovil, Somerset.
John Pearse — 26 Lynwood Grove, Orpington, Kent.
Mrs M. Pearse — Tradewinds, Retreat Drive, Topsham, Exeter, Devon.
B. J. Pengelly — Coads Green, Launceston, Cornwall.
Kenneth Pepperell
Linda Perkin — 16 Cross Park, Brixton, Plymouth, Devon.
Mr & Mrs R. M. Perry — 4 Ainslie Terrace, Camel's Head, Plymouth, Devon.
Dr & Mrs R. J. Pethybridge — Alverstoke, Gosport, Hants.
Lesley Petrie — Woodland Road, Selsey, West Sussex.
Mrs Janet Pettitt — 'Honeywood', 9 South Lawns, Bridport, Dorset.
Tony Pink — Abbots Langley, Herts.
Maurice Piper — 'Firswood', Manor Drive, Kingskerswell, Newton Abbot, Devon.
Mr M. & Mrs D. M. Plush — Keinton Mandeville, Somerset.

Mary & Alan Potter ('Lairseekers')	7 Kings Green Avenue, Kings Norton, Birmingham.
J. & K. Pratt	Exeter, Devon.
Brian W. Pugh	20 Clare Road, Lewes, Sussex.
Mrs P. A. Read	Exeter, Devon.
Mr David R. Rees	7 Grosvenor Close, Torquay, Devon.
Mr & Mrs W. A. Reeves	30 Spencer Road, Paignton, Devon.
Mr Paul Rendell	Okehampton, Devon.
Pat & Ray Roach	19 Overton Gardens, Mannamead, Plymouth, Devon.
Janet Robb	393 Topsham Road, Exeter, Devon.
M. C. Robbins	9 Windsor Road, Southport, Merseyside.
Jean Robertson	Loders, Bridport, Dorset.
Hugh Robinson	Gunnislake, Cornwall.
Sue Robinson	The Old Post Office, Belstone, Devon.
Brian Rodwell	Chudleigh, Devon.
Mike & Mandy Rolfe	Lower Dimson, Gunnislake, Cornwall.
John W. Rundle	3 King's Court, Plymouth, Devon.
Mr & Mrs L. D. Sampson	Okehampton, Devon.
Jenny Sanders	118 Whitchurch Rd., Tavistock, Devon.
Peter Saunders	Ringwood, Hants.
L. B. & S. R. Seabrook	Torrfield, Sheepstor, Yelverton, Devon.
Mrs Maureen Selley	Windyridge, Plymouth Road, Horrabridge, Yelverton, Devon.
Sir David Serpell	Dartmouth, Devon.
Peter Serpell	Roaix, France.
Cecilia Shepherd	Maiden Newton, Dorset.
Sylvia Shepherd	Woodfield Lodge, Torwood Gardens Road, Torquay, Devon.
Mr Michael Alan Shorey	3 Swallow Close, Warminster, Wilts.
Chris & Ronnie Sidwell	3 Fraser Drive, Teignmouth, Devon.
C. G. W. Simmons	37 Westland Drive, Hayes, Bromley, Kent.
M. J. Sleeman	Chandler's Ford, Hampshire.
Roger & Aileen Smaldon	46 Briar Road, Hartley, Plymouth, Devon.
Jim Smale	73 Colt Stead, New Ash Green, Longfield, Kent.
Arthur Smith	Teignmouth, Devon.
Barry & Brenda Smith	81 Leighton Road, Weston, Bath, Somerset.
John E. Smith	Turnchapel, Plymouth, Devon.
Kate Smith	
Mrs Marguerite C. Smith	64 Longlands Drive, Heybrook Bay, Plymouth, Devon.
Maureen Sowerby	9 Gillard Road, Brixham, Devon.
Mrs Gladys Spreadbury	63 Kirby Rd., Portsmouth, Hants.

Mrs R. S. M. Stanton	Walcot, Morchard Bishop, Devon.
Mr David Steer	115 Elgin Crescent, Crownhill, Plymouth, Devon.
Miss Lorraine Steer	20 Brismar Walk, Eggbuckland, Plymouth, Devon.
Arthur Stephens	15 Mostyn Ave., Lipson, Plymouth, Devon.
The Rev'd S. J. Stephens	Oldbury, West Midlands.
Ray & Margaret Stevens	59 Sadlers Way, Hertford.
John Stickland	Shady Coombe, Hoo Meavy, Yelverton, Devon.
Miss Joan M. Stivey	Plymouth, Devon.
Donald H. Symons	1 Dawney Drive, Four Oaks, West Midlands.
Jean Taylor	Wern House, Ynysfforch Hill, Seven Sisters, Neath, W. Glamorgan.
Trevor J. Taylor	Lyndhurst, Linden Ave., Odiham, Hook, Hants.
Mrs P. Theobald	Marston Lodge, Weydown Road, Haslemere, Surrey.
George Thurlow	Ideford, Devon.
Mrs Carole A. Tinkler	96 Chestnut Drive, Brixham, Devon.
Torbay Library Services	
Mrs Jean Trevaskus	9 Cremyll Street, Stonehouse, Plymouth, Devon.
Steven Trevaskus	19 Cathedral Street, Stonehouse, Plymouth, Devon.
Patricia Trout	15 Sycamore Square, Glynswood, Chard, Somerset.
Mr & Mrs C. J. Trudgian	1 Meadow Park, Trewoon, St. Austell, Cornwall.
C. W. Turner	Leat, Lowerdown, Bovey Tracey, Devon.
Tony Van Beveren	6 Broad Walk, Saltash, Cornwall.
Mrs Kate Van der Kiste	Lavandou, Moorland Park, South Brent, Devon.
Mr & Mrs R. Vane	16 Revesby Close, Hartsholme, Lincoln.
Mike & Anne Wadmore	18 Fern Close, Okehampton, Devon.
Rev'd Philip Wagstaff	Harwich, Essex.
Mrs M. G. Wakeford	7 Downsview Road, Portslade, Brighton, East Sussex.
Mr & Mrs G. E. Waldron	38 Waycott Walk, Southway, Plymouth, Devon.
Ian Walker	Greystones, Church St., Barrowby, Lincs.
Alys & Lowri Wall	
Mr Brian Wall	'Wychwood', 39 High Bannerdown, Batheaston, Bath, Somerset.

John Walling	Newton Abbot, Devon.
Ronwen & Don Waring	Llanfair Discoed, Chepstow, Mons.
Alan Watson	Exeter, Devon.
Stuart Watson	10 Torr Close, Hartley, Plymouth, Devon.
Mr I. D. Waugh	Torquay, Devon.
E. & M. Webb	12 Alamein Road, Saltash, Cornwall.
David J. B. Weekes	Honicknowle, Plymouth, Devon.
Mrs I. M. E. Wellington	Wheal Rose, Smithaleigh, Plymouth, Devon.
Val & Brian Whitehead	Brixham, Devon.
Christopher Whittle	Bovingdon, Herts.
Mr Richard Wightman	54 East St., Newton Abbot, Devon.
Mr Terry Wightman	69 Church Road, Newton Abbot, Devon.
Maywyn Wilkinson	12 Wallaford Rd., Buckfastleigh, Devon.
Mr Graham L. Willmott	18 Fairview Avenue, Laira, Plymouth, Devon.
Gerald Wills	6 Elm Green, Hemel Hempstead, Herts.
Peter Wills	
Christine Winter	251 Victoria Road, St. Budeaux, Plymouth, Devon.
Mrs Diane Woodford	Coulsdon, Surrey.
Alison Wraith,	Tavistock, Devon.
Mrs Rosalind Wright	16 Carmarthen Way, Rushden, Northants.
Christopher Wynn	Sidmouth, Devon.
Mr & Mrs J. Yandle	Wincanton, Somerset.
Douglas J. Yardley	'Stonecroft', 69 Bellevue Rd., Wivenhoe, Essex.

✷✷✷✷✷